gerd arntz
graphic designer

edited by **ed annink** and **max bruinsma**

oıo publishers, rotterdam 2010

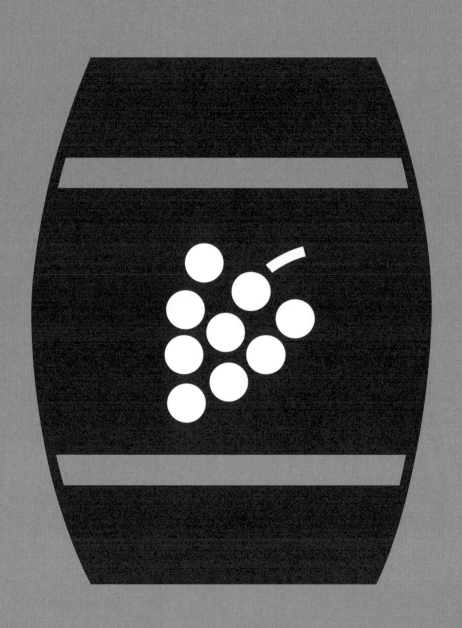

Doormats and crockery

In 1991, I took two Gerd Arntz drawings from Mart.
Spruijt's document file, digitized them and had them
projected onto doormats. It seemed to me that Arntz's
images could be applied to other products as well, thus
creating new meaning and furthermore encouraging
awareness of the artist and his work. DMD (Design
Manufacturing Distribution), at that time a newly started
product design studio annex distributor, incorporated
the doormats in its new international consumer
products collection, entirely designed by Dutch artists.
The doormats were accompanied by a laudatory manual
retracing the design's origins to Gerd Arntz. Still in
production, the doormats are distributed by Dutch
design brand Droog.

A few years ago, I came into contact with Kwantum,
a discount store boasting some 100 large stores across
the Dutch-speaking Lowlands. I thought it would be
great if Gerd Arntz's Isotypes would show up in mass
consumer products, thus providing his imagery with
a very large audience. By now, seventeen different
pieces of white china crockery decorated with silvery
projections of Arntz's Isotypes have been produced,
under the tongue-in-cheek designation 'I want the one
with the egg'.

Introduction
by Ed Annink

It was in 1989, a few years after I completed my studies at the Royal Academy of Arts in The Hague, and by then working with a couple of friends in our freshly-started and modest graphic and environmental design studio, that I came across a document file at Mart. Spruijt printers while researching logo-types. The file revealed a great number of elegantly stylized images in a series of items ordered in different categories. They were commissioned by Otto Neurath (1882-1945) and drawn by Gerd Arntz (1900-1988). I was immediately struck by these powerful, informative and strongly communicative images, almost all of which seemed to effortlessly survive the distance in time between 1925 and 1989.

My interest in Gerd Arntz's work was, above all, based on his masterly craftsmanship, his thorough commitment to society, and his collaboration with Otto Neurath. I try to picture the way Arntz was working in his studio; his obvious political, anti-capitalist and anti-militaristic work wouldn't necessarily have been received positively by everyone. Very much in tune with the time, this conscious positioning of the graphic artist as a political activist was meant to contribute to discussions and comments on the pressures of industrialization and, later on, the rise of Hitler's national socialism. Gerd Arntz's starkly stylized work led Otto Neurath to invite the artist to collaborate in the design of a pictorial system for knowledge transfer based on statistics and diagrams – a system that would make information concerning the relentless development

of industrial, economic and sociocultural knowledge available to all. Neurath's motto – 'Words divide, images unite' – must have struck a chord with Arntz. Working together, the two men developed an impressive range of new, informative images directly addressing everyday society. Still, it's not so much the sheer number of drawn images which begs respect; it's above all the proposal to transfer information through images, as well as Arntz's impressive mastery – motivated by an impassioned commitment to society – and his desire to share this 'knowledge-through-imagery' with the public at large. Proponents of a radical socialism, both Neurath and Arntz were ahead of their time in putting forward a proposal embraced since by the world's communications and information communities. Today, we get our information through road signs, signing systems in public spaces, 'handle with care' pictograms on cardboard boxes, pictorial instructions of DIY products, and sports pictograms at the Olympics.

In 2008, collaborating with Laura van Uitert and Max Bruinsma, I was able to compile a book titled *Lovely Language* which was based on the ideas of Otto Neurath and Gerd Arntz. In it, we explored current as well as future uses of images in communication and information. A tremendous amount of imagery has been produced since 1925, especially following the year 1982, when the internet caused a surge in the production and distribution of imagery. Today, one and the same purpose can be served by such a great variety of imagery – take the many

different images indicating the men's room – and, conversely, an abundance of specific imagery used for a range of different purposes – take the men's room figure indicating the treatment room of a medical doctor – so much so that one might conclude we have a Babel-like confusion of a pictorial kind on our hands: would I have to pee in the doctor's treatment room? In today's globalized and inextricably interwoven world, in which many cultures and subcultures live and work together, images can contribute to efficient and informative communication.

It might be that Neurath's and Arntz's specific goals and ideals are no longer in tune with today's diversity and its many pictorial perceptions. However, amid the enormous abundance of our present-day imagery, Gerd Arntz's clear-cut and meticulously applied symbols still touch us as a breath of fresh air.

gerd arntz

applied
bildung

Gerd Arntz, around 1978, in front of posters for the activist magazine *Klassenstrijd* ('Class Struggle') which uses parts of Arntz's series of prints 'Twelve Houses of this Time' from 1927.

Gerd Arntz in his Vienna studio,
drawing the symbol 'unemployed', 1931.

Gerd Arntz (1900-1988)
Applied *Bildung*

by Max Bruinsma

Born in a German family of iron manufacturers, Gerd Arntz
decides early in his life to take a different course and become
an artist. In Düsseldorf, where he lives since his nineteenth,
he joins a movement which wants to turn Germany into
a *Raden Republik* ('council republic'), a radically socialist state
form based on direct popular democracy. As a socially inspired
and politically committed artist, Arntz joins the Cologne based
'progressive artists group' (*Gruppe progressiver Künstler Köln*)
and depicts the life of workers and the class struggle in
abstracted figures in woodcuts. Published in small avant-garde
magazines, his work is noticed by Otto Neurath (1882-1945),
an economist and social scientist and founder of the Museum of
Society and Economy (*Gesellschafts- und Wirtschaftsmuseum*)
in Vienna, Austria. Neurath had developed a method to
communicate complex information on society, economy and
politics in simple images. For his 'Vienna method of visual
statistics', he was looking for a designer who could make
elementary signs, pictograms that could summarize a subject
at a glance. In 1926, the museum takes part in the international
exhibition 'GeSoLei' (*Gesundheitspflege, soziale Fürsorge und
Leibesübungen* – health care, social care and gymnastics)
in Düsseldorf, Germany. Concurrently, the young artist Arntz
presents his latest work in the same city, showing wood-cuts
such as *Mitropa*, a critical commentary on class society.
Although at the time Arntz is unaware of Neurath's theories,
his style mirrors the Viennese economist's principles of clarity
and 'legibility'. Neurath visits Arntz's exhibition and sees the

Mitropa, 1925
The company Mitropa (from the German word 'Mittel-europa') is best known as caterer of various German rail-road companies for most of the 20th Century. In *Mitropa* Arntz depicts the division between rich (against a clear background) and poor (in a gloomy environment). He carved this woodblock in 1925, and made a series of black and white prints from it (*see page 102*). After completing the print run, Arntz used to paint his wood-blocks, thus creating colorful reliefs, but this one he only painted in the 1970's.

potential of this artist for his own work. He arranges to meet Arntz in his studio and asks the legendary question: 'How much do you cost?' The answer is obviously satisfactory, because Neurath invites Arntz to join him in further developing his method, which will eventually become known as ISOTYPE, International System Of TYpographic Picture Education. In 1929, Arntz is definitively appointed to the *Gesellschafts- und Wirtschaftsmuseum* and, 28 years old, moves to Vienna. During his career, Arntz designed around 4000 different pictograms, or *Signaturen* as they were called by Arntz and Neurath, and abstracted illustrations, or *Leitbilder*, for this system. At the same time, he was working with Neurath and his collaborators on designing exhibitions and publications for the Vienna museum.

Vienna after the First World War is a city in turmoil: the Habsburg Empire has collapsed and all that remains of the Austrian-Hungarian double monarchy is the *Bundesland Österreich* (Federal State of Austria), a small mountain republic with Vienna as its Capital. In this intellectual and cultural centre – a head too big for its body –, an Austrian variant of Marxism is invented and a socialist municipal government transforms the once aristocratic city into 'Red Vienna'. The economist Otto Neurath, who during the 'Great War' had specialized in 'wartime economics' switches to 'civil economics' and helps the city government to organize solutions for Vienna's exploding housing problem. His major passion is to disseminate scientific

Exhibition with visual statistics at the entrance
of the *Volkshalle* ('People's Hall') in the new Vienna
Town Hall, circa 1927.

knowledge to a large audience, and the medium for his ideas as social-educationalist becomes the '*Gesellschafts- und Wirtschaftsmuseum*', which he founds in 1925 with support of the municipality. A keen believer in the informative power of statistics, Neurath asks himself: how to visualize numbers? A good graphic should attract attention by its thoughtful lay-out, its clear typography and should depict its subject in such a way that the viewer can draw their own conclusions without having to refer to text. Socialist Vienna is an internationally acclaimed center of social housing and workers' emancipation and Neurath's visual statistics are adamantly meant as being an instrument of this emancipation. Arntz's own political attitude fits this context seamlessly.

In Vienna, Arntz improves the quality of design at the museum and soon becomes involved, not only in making exhibitions but also in designing the first visual statistics as charts to be displayed in the museum or to be published in books or *Mappen*, loose-leaf collections of charts. Neurath's staff at the museum consists of around 25 people in the early 1930s, of which the drawing department counted 3 to 6 men, apart from Arntz. He had meanwhile introduced linoleum-cut as the means for reproducing the symbols that were at the core of Neurath's 'Vienna Method' of visual statistics. Arntz's designs were transferred by calqued paper onto the linoleum, cut out and then sent to the in-house printers. Outlining the lay-outs and inserting texts and symbols was the task of assistants, among

which frequently were students of the Bauhaus, where Neurath occasionally lectured. The museum's printing workshop was equipped with two presses for printing hand-set type, clichés and the linocuts, and manned by three printers/typesetters. In addition, there was a photographer handling the enormous technical camera, and a carpenters' shop where models and other objects for the exhibitions were manufactured. All in all, it was a lively and extended workshop, in which Gerd Arntz acted as design director.

The most notable publication of the museum is the loose-leaf collection of a hundred charts in the *Atlas Gesellschaft und Wirtschaft* of 1930. The 'atlas' is a text book example of the 'Vienna method' to present generally accessible information with the aid of images, regardless of language barriers. It is Neurath's and Arntz's major collection of visual statistics, and was used as *Elementarwerk*, meaning as an example of how to make complex information accessible, using a standardized visual language. The 100 charts conjure up an image of populations of countries and continents, of world powers and their political and military relations, of trade and industry, the growth of cities and their social structure and workers' conditions. Everything is systematically visualized in directly recognizable diagrams.

As a model for visual statistics, the atlas is a success. In 1931, this leads among other things to an invitation to come to the

young Soviet Union and set up an institute for visual statistics in Moscow, Isostat, an institution which directly reports to the Soviet Central Committee. Neurath and Arntz regularly travel to Moscow in the early 1930s, and Arntz takes his family with him on several occasions. The work done in the context of Isostat is intensive and extensive – Neurath and Arntz direct a group of a few dozen co-workers – and may be considered an early success for visual statistics. In the same period, Neurath also acquires commissions from other European countries and the United States, where his pupil Rudolf Modley, a former assistant at the Vienna museum, starts a similar institute and introduces his own variant of the 'Vienna method'.

The Austrian elections of 1932 dramatically change the political situation in Vienna. The Austrian fascists take over the national parliament and Neurath starts looking for an exit. He finds it in The Hague, Holland, where he registers the International Foundation for Visual Education in 1933 as a legal extension of the Vienna museum, which is re-baptized 'Mundaneum Institute'. February 1934, a general strike in Vienna is crushed by right-wing militias and the national army in a bloody street battle, and the *Gesellschafts- und Wirtschaftsmuseum* is closed. By then the museum's content, down to the smallest printing press, has been evacuated and the collection is later transported to The Hague. Neurath, who is in Moscow at the time of the crisis, travels to Holland instead of Vienna as do Arntz and his family and two collaborators, also from Moscow,

Gerd Arntz (l, 1930s) and Rudolf Modley (r, 1930s), Isotype symbol for 'unemployed'

Although structurally quite similar, the two signs express rather different emotional conditions. The capped head of Arntz's unemployed worker looks slightly bent, but actually isn't: the artist moved the head a bit forward, so it looks as if the man has lowered it between his shoulders – a sign of passive acceptance. But his back is straight, and with his hands in his pockets, the man's air of passivity becomes almost defiant. He's idle, but not crushed. Modley's unemployed, on the other hand, clearly has his head bent, as in submission to his fate. This emotional expression is reinforced by the bend in his arm, which suggests a crooked back. This worker is not only idle, he is devastated. One could say that both pictograms represent two words for the same thing, stressing slightly different aspects of it. Just like the words 'idle' and 'inactive' are synonyms, but not quite the same. Another way of describing the difference between Arntz's and Modley's pictograms is as dialects or vernacular: the words are fundamentally the same, but written and pronounced differently, whereby one dialect clearly has a more dramatic ring than the other.

PRODUKTIONSFORMEN
GESELLSCHAFTSORDNUNGEN
KULTURSTUFEN
LEBENSHALTUNGEN

GESELLSCHAFT
UND WIRTSCHAFT

 farbige Tafeln

Bildstatistisches Elementarwerk
des Gesellschafts- und Wirtschaftsmuseums in Wien

Verlag des Bibliographischen Instituts AG. in Leipzig

a little later. The Soviets offer him to stay on, but the radical democrat Arntz had become suspicious of what he called the 'party dictatorship' and decides to leave. Neurath's later partner Marie Reidemeister – then a 'transformer' in his team, meaning she edited the often complex information Neurath wanted to convey into discrete sets of data – joins them from Vienna in the same year.

In 1936, the reorganized Mundaneum Foundation in The Hague counts four staff members, assisted by a Dutch secretary. Neurath continues publishing and in an article in the Dutch socialist magazine *De Delver*, in 1935, he uses the term 'ISO-TYPE' for the first time. In this article, he describes the range of symbols and signs that has been developed by Arntz and colleagues such as the graphic artist Peter Alma so far as constituting the letters of a future alphabet, which will contribute to 'the creation of a lexicon of signs and a sign grammar'. The first international introduction of the system is the English edition of *International Picture Language – the first rules of Isotype* in 1936. It is immediately followed by the booklet *Basic by Isotype*, which applies the Isotype method within the context of C.K. Ogden's simplified 'Basic English'. Such publications, and commissions from the US for *Compton's Pictured Encyclopaedia* and government health campaigns provide some perspective – and income. Arntz and his wife start taking a Linguaphone course in English.

gerd arntz, applied bildung

A meeting at Neurath's Mundaneum office,
267 Obrechtstraat, The Hague, 1939.
Left: Marie Reidemeister and Otto Neurath
Right, in white coat: Gerd Arntz

In these last years before the war, the Mundaneum Institute develops two exhibitions, which are shown at the three main outlets of the Dutch luxury department store De Bijenkorf in Amsterdam, Rotterdam and The Hague. 'Around Rembrandt' is organized on the occasion of the Dutch Queen's 40-year reign in 1938 and a year later 'Rolling Wheel' celebrates Dutch transportation and the National Railways. Meanwhile, Neurath is invited by the American publishing house Alfred A. Knopf to elaborate on his ideas on social affairs, which he does in a 'picture-text-style book' which combines clear and simple wording with visual statistics: *Modern Man in the Making*, published in 1939.

The year 1940 seems to start well – Holland remains neutral at first in the clash between Germany and other European countries and the Dutch translation of *Modern man in the making* appears. But Holland does not escape the war, as it did in 1914. When Gerd Arntz visits Neurath's and Reidemeister's home in The Hague on May 15th, the day of the Dutch capitulation to the German forces, he finds them gone – they have fled to England the night before, leaving everything behind. Just before the German *Sicherheitsdienst* ransacks Neurath's house, most of his personal belongings are salvaged by friends and, with the contents of the Mundaneum, eventually stored at the Dutch Central Bureau for Statistics (CBS). The Bureau's head, Philip Idenburg, saw not only a social but also a commercial potential in the work of the Mundaneum foundation, and

Collaborators of the Isostat institute, Moscow, 1933.
First row, 2nd right: Gerd Arntz
Second row, 2nd right: Peter Alma

Season's greetings card from the International
Foundation for Visual Education in The Hague,
designed by Gerd Arntz, 1940.

so, within a month, the 'Dutch Foundation for Statistics' is initiated, housed at the CBS and manned by former CBS manager Jan van Ettinger as director, with Gerd Arntz as head of the design department.

During the war, the Foundation initiates several publications of visual statistics on 'Prosperity and industry in the Netherlands', obviously keeping a safe distance from the new political and ideological reality in the occupied Netherlands. The focus of the Foundation's publications is on Holland as an industrial nation, rather than the clichéd image of a country of farmers and traders. In the early years of the occupation this image is propagated on trade fairs and exhibitions, and Arntz provides the accompanying illustrations, visual statistics and art direction. But in 1943 this relative calm comes to an abrupt end when Arntz – still a German citizen – is drafted into the German army. He is sent to Normandy as a driver in a regiment that attempts to hold back the invading allied forces. A day before Paris is liberated, Arntz is sent to the French capital, where, under fire, he convinces his fellow soldiers to surrender to the Americans. As a wounded prisoner of war, the former radical socialist ends up in a military hospital where a nurse – a member of the French *résistance* – gives him a copy of the French communist newspaper *L'Humanité*, no doubt to teach this German soldier a lesson. The absurdity of war.

ISOTYPE INSTITUTE LIMITED BY GUARANTEE

Board of Management: V. S. SHEPHERD, Chairman H. L. EDWARDS, Deputy Chairman M. WICKHAM, Treasurer J. DIAMOND
Secretaries: O. NEURATH, Austrian M. L. NEURATH, Austrian Reg. Office: CRITCHLEY, WARD & PIGOTT, Boswell House, OXFORD

GERHARD ARNTZ Esq.
31 G, 725 449 Lab German
8484 Labor Supervision Co,
A.P.O. # 562

this letter enclosed in an envelope
to PRISONER OF WAR INFORMATION BUREAU P.W.I.B. France, A.P.P. # 887

My dear Arntz ,
 First of all our congratulations that you came through the
Nazi period alive and that you are alive now . We are in correspon=
dence with your wife and very glad, that we were able to provide
her with a testimonial , which declared that all of you are Antina=
zis since I knew you and that all the information we got about all
of you during the war told that you are remaining as we knew you
before . Your wife hopes to get the two men of the household XXXXXX
back in not too far a future .
 I discussed your case with a friend in the American Embassy
and our Institute is trying to get you out for continuing your work.
We need you as collaborator either here or in Holland , where we now
reorganize our Foundation in some co-operation with the new Dutch
institute . All old friends are busy to help us, everything looks
well . Should we not get your release quickly , we should ask ,
that the American authorities give the permission that you work
for us in your camp . The question is, whether you would get the
needed material there, paper, pencils, compass etc or whether we
have to provide you with all that . Please answer by return
my American friends will write you, how you should formulate the
address .
 I hope we shall succeed in this our attempt . Mary and I
interned by the British authorities before they discovered that

we were real Antinazis got the permission to make transformations
for our American publisher and we got even Dollars paid - a great
show in the camp , as you can imagine . The American authorities
are usually not more rigid than the British are .

In short our adventures . You remember 14th May 1940 ,
resistance stopped - Nazis invaded the remaining Holland . We could
not reach you and tried to escape . Some shooting in the streets.
We reached the harbour , no preparation for evacuation. We finally
saw a motor-life-boat and jumped into it. 50 persons instead of 25.
Burning Rotterdam , exploding ammunition dumps at The Hague . Calm
sea . Next day in the Neighbourhood of Dover a British destroyer
picked us up . First interned . Famous people intervened , Einstein,
Huxley,Earl Russell etc . XXXXX Finally the Oxford University invi-
ted me to lecture . Released,we married. English friends, Stebbing
as chairman (she died in the meantime) organized the Isotype In-
stitute . We prepared book illustrations, made films, etc in grand
style . Now we moved to 194 Divinity Road,OXFORD into a bigger
building, where we have some rooms for our collaborators and also
for our home . Friends of ours bought the whole mansion for this
purpose . There is a dozen collaborators now. We have a fine team
of draughtsmen, who are expecting you whose work the appreciate
very much . We are just starting with an animation institute ,
which we organise together with a well known film producer . Every-
thing goes on very well . My son is in the USA , second Dr degree ,
he is now lecturing Statistics at the University College . Our
nearest friends in Holland are alive .

Now we have to get you back . Of course we shall immediately
try to do something for your wife and son . Be sure of that . Up
to now everything is rather difficult to manage, but within a short
time transport etc will be rather normal as far as Holland is
concerned .

Have you any particular wish ? What we are permitted to send
you we shall send you, it would be a pleasure for us to do so .
We are healthy ,sitting happily on a hill in Oxford's suburbs
with a view on the hills . We have a great institute's library
and also a library of our own . We have fine collections of maps,
pictures etc . I am writing books on Visual Education etc . With
best wishes and kind regards from both of us,ever yours

Otto Neurath

Meanwhile, Otto Neurath tries to help his old comrade from London, but can't prevent that Arntz spends the best part of 1945 and '46 as a prisoner of war. When, after more than three years, he enters the Netherlands again, he is immediately 'put in holding' as an alien. It takes a phone call from CBS director Idenburg to the Minister of Justice to release him the next day.

After the war, the Foundation more and more focuses on consumer and market research, working mainly in commission for such clients as the building and chemical industry, the Bijenkorf department store, the economic communication department of the Dutch government and Unesco.
Arntz continues to work as he did before the war, although in terms of its original intentions, the output of the Foundation constitutes a breach with the Mundaneum era. Still, Arntz and his assistants pride themselves in delivering well-designed visual statistics according to the Isotype method. Meanwhile, he continues working on his 'free' expressions, although the overt political messages become more veiled. He takes on illustrating classics such as Ovid's *Metamorphoses* and Voltaire's *Candide*, and reinterprets old themes such as the 'Dance Macabre' and the 'Ship of Fools'. The ideological drive to criticize the powers that be, which inspired his earlier work, is now translated into a mature insight in the *condition humaine*.

Twelve years with Otto Neurath and another twenty-five years with the Dutch Foundation for Statistics have resulted in a vast body of work and a great variety of symbols and illustrations. In 1976 this oeuvre is entrusted to The Hague's Municipal Museum, where Flip Bool and Kees Broos organize a first overview in their exhibition *Gerd Arntz – critical graphics and visual statistics*, followed in 1980 by a more extensive selection of *Symbols for education and statistics* in a publication by Broos, issued by Mart. Spruijt printers.

The work of Arntz and Neurath is an inspiration for contemporary artists and designers engaged with today's social issues. Arntz himself, however, would shun the term 'engaged art' – he considered himself a designer, not an artist. On the other hand, he was a proud member of the Dutch 'Federation of Applied Artists'. Art or design, the aim was to enlighten people, or in German terms to help them in developing their *Bildung*, their education as well-informed citizens, and enable them to critically assess visual information. Today, a generous selection of Arntz's artistic legacy, administered by the Municipal Museum of The Hague, is available on-line, as a tribute to a modest but seminal artists and a source of inspiration for artists and designers alike.

This text is based to a large extent on a lecture by Gerd Arntz's son Peter Arntz (1924-2009) in 2007, and an interview shortly before his death, in July 2009.

The board of artists' society 'De Grafische' around 1960.
Seated left: Gerd Arntz
Standing on the right: graphic artist M.C. Escher, a very
good friend of Arntz's

Gerd Arntz with Flip Bool at Mart. Spruijt printers, Amsterdam, in 1981, inspecting the ring-bound publication of *Symbols for education and statistics* by Spruijt, 1979.

Structural drawing of the symbols for man and woman,
showing their proportions.

34

20

10

23

19

30

17

10

120

25

23

27

3

25

Illustrations by Gerd Arntz for the socialist union magazine *Die Proletarische Revolution*, 1928.

DIE PROLETARISCHE REVOLUTION

No. 1 · 3. JAHRGANG
JAN. 1928
PREIS 15 PFG.

ORGAN FÜR DIE REVOL. INTERESSEN DER ARBEITERKLASSE
HERAUSG. VON DER ALLGEM. ARBEITER UNION EINHEITSORG.

Prosit Neujahr Hindenburg! — Das Volk hungert!

Die Tragödie von Colorado. — K. P. D. für Fürsten, Pfaffen, Justiz und Polizei.
Der Frankfurter Bürgermeister Gräf (Sozialdemokrat) läßt Erwerbslose hungern!
„Ein Schiedsspruch für die Unternehmer."

„Ordnung herrscht in Berlin."

Was war, was ist und was wird sein?

Mit dem Zeichen der 12 Glockenschläge wurde das Jahr 1927 beendet und das Jahr 1928 begonnen. An nackten Brüsten liegend und die Sektpfropfen knallen lassend, feierte die Bourgeoisie in Hotels und Bars den Uebergang vom alten in das neue Jahr. Der Arbeiter saß bei minderwertigem Gesöff und bedaurte sich den Kopf, um die Strapazen und Prügel, die das alte Jahr ihm bescherte, vergessen zu machen.

Die Bourgeoisie hat dieses Neujahr zu feiern alle Ursache gehabt. Im Jahre 1928 kann sie doch die Zehnjahresfeier ihrer Republik begehen und den Sieg über den niedergeworfenen Spartakus feiern. Zugleich wird die Bourgeoisie die mit Lobeshymnen überschütten, die mit brutaler Macht das vor 10 Jahren sich erhebende Proletariat niederknüppelten, die Noske, Scheidemann, Ebert & Co. Soweit sie noch leben werden diese Hyänen der Arbeiterbewegung die Dankbarkeit des Bürgertums mit stolz erhobenem Haupt und geschwellter Brust entgegennehmen und versuchen, auch das Proletariat zu den Jubelfeiern zu animieren. Zum Teil wird diesen Arbeiterverführern dies natürlich auch gelingen. Für uns ist es ganz klar, daß die an den Feiern teilnehmenden Proletarier Knechtsnaturen sind, die noch über die Prügel, die sie bekommen, lachen. Sie werden die hundserbärmliche Rolle die sie während der letzten neun Jahre spielten, auch dieses Jahr wieder spielen, ja sie werden sich rühmen, die Stützen der Republik zu sein, einer Republik, die doch ihre Arbeiterfeindlichkeit jeden weiteren Tag ihres Bestehens deutlicher zeigt. „Arbeiterführer" werden sich rühmen, daß diese Republik „ihre" Arbeit ist, da sie es waren, die die Novembererhebungen, die Spartakuswoche, die Münchener Räterepublik, den Mitteldeutschen Aufstand usw. niedergeschlagen haben, die Inflation überwinden halfen, daß sie für die Gesundung der Wirtschaft und deren Rationalisierung in all den 9 Jahren eintraten. Selbstverständlich wissen wir, daß, während die Arbeiter immer tiefer ins Elend gestoßen werden, die Aktien der Kapitalkönige höher und höher steigen; wir wissen auch, daß, während Hunderttausende von arbeitswilligen Proletariern auf der Straße liegen, Millionen größtenteils gut gewerkschaftlich organisierter Arbeiter in der Eisenindustrie, im Bergbau und in der chemischen Industrie 10–12 Stunden täglich frohnen müssen.

Durch die billigen Arbeitslöhne, die lange Arbeitszeit, durch den Streikbruch gegen die englischen Bergarbeiter, durch die geringen Ansprüche der Arbeiterschaft und vor allem durch die tatkräftige Förderung der Rationalisierungsbestrebungen der deutschen Industrie durch die Gewerkschaftsbonzokratie konnte sich die Bourgeoisie etwas erholen, kann sie Hochkonjunktur machen. So hat die Bourgeoisie mit ihren Diplomaten, Regieren und „Wirtschaftssachverständigen" alle Ursache, zu jubeln. Und ihnen gleich tun können es die beschenkten und gutbezahlten Sklavenhalter.

Das Proletariat hat keine Ursache in diese Jubel-

(rechte Randspalte, vertikal:) Das revolutionäre Programm bleibt ein armseliges Stück Papier, wenn das Mittel fehlt, es zu verwirklichen. Das Mittel sind die Betriebsorganisationen und das Rätesystem!!

von Arntz, Düsseldorf

komödie einzustimmen. Es hat sich vielmehr die Frage zu stellen:

Was war, was ist und was wird sein?

Zur Frage eins: Was war? muß sich das Proletariat ins Gedächtnis zurückrufen, daß es sich nach den 4 Elendsjahren des Krieges, wo es wie Ratten in den Schlammlöchern hauste, in denen Mord an seinen Klassenbrüdern als Tapferkeit gestempelt,

jede Schandtat als Kriegslist gefeiert wurde, aufraffte, um die Gesellschaft, für die man um zugewiesene Brot-, Fett- und Kohlenrationen kämpfte, zu stürzen, zu beseitigen. Daß, als das Wort Revolution durch die Lande hallte, das Spießbürgertum bis ins Mark erschauerte und fluchtartig sich verkroch, um, nachdem die Arbeiter ihr Schicksal in die Hände der Führer legten, vorläufig jede Forde-

DIE PROLETARISCHE REVOLUTION

No. 9 · 3. JAHRGANG
APRIL 1928
PREIS 15 PFG.

ORGAN FÜR DIE REVOL. INTERESSEN DER ARBEITERKLASSE
HERAUSG.
VON DER ALLGEM. ARBEITER UNION EINHEITSORG.

Was ist das Parlament?

RÄTEMANDAT oder DIÄTENMANDAT?

UNPARLAMENTARISCHES GEBUNDENES — PARLAMENTARISCHES UNGEBUNDENES

Euer Vertrauen zu den Führern, zu Parteien und Gewerkschaften führte euch dahin, wo ihr heute seid. Ihr seid heute da angelangt, wo die Barbarei beginnt. Eure materielle Not, euer soziales Elend vergrößert sich von Tag zu Tag. Die Reaktion sitzt durch eure Demütigkeit, durch eure pietätvolle Harmonieduselei fest im Sattel. Ihr wartet noch immer auf Wunder, die durch eure Führer kommen sollen. Ihr gedenkt noch immer durch den SPD-Quatsch — „durch Demokratie zum Sozialismus" — das Ziel zu erreichen. Als Sozialist für den Sozialismus kämpfen, heißt: Selbsterkennen und Wollen, heißt jede Autorität bekämpfen, da jede Autorität zum Staatsgedanken neigt, um herrschen und regieren zu können. Im Sozialismus darf die arbeitende Klasse regiert werden, sie muß selbst regieren; die hat jeder einzelne selbst zu leiten und sich einzufügen ins Getriebe.

Darum weg mit den Führern, die das Proletariat zu jeder Zeit der Reaktion ausliefern. Blickt um euch, laßt die Jahre von 1914 bis heute an euch vorüberziehen, vergleicht die Versprechungen eurer Führer nicht und vergleicht dieselben mit ihren Taten. Stehen nicht jedem die Haare zu Berge bei solchen Betrachtungen? Packt euch nicht die Wut, wenn ihr seht, wie eure persönliche Energie im Interesse einzelner verpufft wird, für einzelne, deren ganzer Ehrgeiz ist, einen Regierungsposten im kapitalistischen Staate zu ergattern, in einem Staate, wo die Gesellschaft in Klassen geteilt ist, in Ausbeuter und Ausgebeutete, wo erstere geschützt und letztere für vogelfrei erklärt werden? Die letzteren werden mit Hilfe der Gesetze, Polizei, Gerichte und des Militärs unterdrückt. Eure Führer erklären euch, diese Institutionen verteidigen die Kultur. Könnte man nicht laut aufschreien, wenn man das Wort „Kultur" hört? Wie wirkt sich die heutige „Kultur" für das Proletarierinteresse aus? In Gestalt von Gummiknüppeln, Karabinerstößen, Gefängnis- und Zuchthausstrafen, denen die Todesstrafe folgt, bekommt das Proletariat seinen Anteil der heutigen „Kultur". Wollt ihr euer trauriges Los verbessern, so müßt ihr die Führer bekämpfen, die die Restaurateure der heutigen „Kultur" sind. Durch eure Lammesgeduld und Verzagtheit sitzen noch hunderte in Gefängnissen. Diese Proletarier, die Fleisch von eurem Fleisch und Blut von eurem Blut sind, wurden eurer Trägheit wegen verurteilt; sie wollten das Beste für sich und ihre Klasse, durch die Phraseologie eurer Führer zum Opfer der Justiz. Die KPD.-Führer gleichen denen der SPD. aufs Haar. Jene leisteten den Bourgeoisie die Dienste bei der Ermordung des Vortrupps der Revolution. Die anderen haben einen großen Teil Schuld an den Opfern der Justiz, wußten sie doch, daß ihre Phraseologie nur für eigene Interessen gedroschen wird, daß diese Phrasen für die Befreiung der Arbeiterklasse unbrauchbar sind. Besinnt euch auf eure Klassenzugehörigkeit, geht deßhalb nicht mit Schwarz-Rot-Gelb und Rot-Front mitpagieren. Es sind typische Staatsmänner, elende

rutterkrippenjäger, die sich jeder Situation anpassen. Vor der Wahl wurden sie nicht fertig, sich gegenseitig mit Schmutz zu bewerfen. Während der Parlamentstätigkeit ging alles in größter Harmonie vor sich. Die abgelaufene Parlamentssaison war ein sicheres, gutes Geschäft für eure Führer. Betrachten wir, wie sich die Mitglieder der Quasselbude, 493 an der Zahl, aborierten, was sie und euch daher herankam, so ist erstens festzustellen, daß von der über 5000 Anträgen die zum Teil im Plennum verkehandelt oder in den 32 Ausschüssen „erledigt" wurden, 363 neue Gesetze entsprungen sind. Außer diesen über 5000 Anträgen wurden von den Parteien 250 Interpellationen eingebracht, die ein Opfer des Papierkorbs ist. Ein sehr angenehmer Erfolg für die betroffenen Parteien ist, daß während der 39 jährigen Parlamentssaison 5 Regierungen kamen und gingen. Bedenkt man, daß jedes Regierungsmitglied mit seinem Sturz eine jährliche Pension von 10 000 27 000 Mark bezieht, so ist der Kampf der Parteihäuptlinge um die Regierungsfutterkrippen zu verstehen. Das Versprechen der Wahlredner, daß das Parlament für die gutgläubigen Wähler da sei, daß er ihn dort vertrete, hatte zur Folge, daß 50 000 Wähler Petitionen an das hohe Haus richteten, die alle in den Papierkorb flogen. Die Anträge, Interpellationen und Petitionen brachten mit sich, daß die Beherrscher des hohen Hauses, die euch nach der Wahl wieder Mord zeigen. 15 000 engbedruckte Protokollseiten vollgequatscht haben. Wer von diesen Männern denkt oder glaubt, diese Reden hätten die Parlamentarier insonders gebracht, der irrt gewaltig. Die Parlamentarier sind mit die größten Faulenzer und Parasiten, die am Körper des Volkes nagen. Bedenkt man, daß der Reichstag 39 Monate beisam-

men war, daß in diesen 39 Monaten 413 Sitzungen stattfanden, so ergibt sich daraus, daß jeder Abgeordnete in den 39 Monaten 2 Jahre und 1 Monat Ferien hatte. Der Gehalt, (Diäten) 750 Mark monatlich und Fahrschein 1. Klasse (mit Schlafwagen) weiter liefen. Abgeordnete, die während der Ferienzeit an Ausschußsitzungen teilnahmen, bekamen eine Extra-Schwerarbeiterzulage von 25 Mark pro Sitzung. So erhielten die 493 Abgeordneten in den 39 Monaten die nette Summe von 15 Millionen Mark an Lohn, ferner kommen hinzu: 5 Millionen Mark für Freikarten, 12 000 Mark für „Ersatz von Schlafwagenkosten", 6000 Mark für die Benutzung der Kraftpost und 25 000 Mark für Benutzung von Luftfahrzeugen. An diesen Summen ersieht der Wähler, wie diese Gesellen für sich alle Bequemlichkeit in Anspruch nehmen. So benötigten diese 493 Blutsauger 352 Beamte und Angestellte, die 9,6 Millionen Mark Besoldung erhalten. Selbstverständlich gehen diese Menschen immer mit der Modernisierung, so wurden für die Küchenanlage des Reichstagsrestaurant 150 000 Mark verausgabt und für die Erneuerung des Teppichbelages im Sitzungssaal 50 000 Mark verpulvert. Erstens scheint für ein parlamentarisches Gehirn besonders angebracht zu sein, denn ein „idiotisches" Gehirn muß vor Erschütterung bewahrt bleiben. Rechnet man diese Summen mit den nichtaufgeführten zusammen, so hat dieser Reichstag dem arbeitenden Volk 33 Millionen Mark gekostet.

Und fragen wir uns, was sind dies für Menschen, die so ans Volk zehren, so sind es laut Zurufen, die sich die „Herren"-„Kollegen" gegenseitig leisteten: „Lausbuben — unverschämte Bengel, — Dummköpfe und Idioten!"

Und diese Menschen, die sich selbst als die minderwertigste Gesellschaft im Lande bezeichnen, treten in den nächsten Tagen und Wochen vor euch hin und sagen: „Wählt uns, wir sind die Volksbeglücker."

Arbeiter, alle anderen, an denen idiotische Verunglimpfungen festgestellt werden, sperrt man ein Irrenhaus. Und ihr wählt euch solche Menschen als Vertreter, die für eure Befreiung wirken sollen. Wir fragen euch immer und immer wieder, die ihr doch geistig höher stehen sollt als diese Lausbuben, unverschämten Bengels, Dummköpfe und Idioten, mißbrauchen lassen? Wir fragen euch, habt ihr in 39 Monaten auch 2 Jahre, 1 Monat Ferien, könnt ihr auch 1. Klasse mit Schlafwagen, Flugmaschine fahren, wenn ihr

AUGE

Auge

STREICHHÖLZE

Streichhölzer

MAISKOLBEN

Maiskolben

KIPPER

Kipper

MEXIKANER

Mexikaner

KETTE

Kette

Memory game with cards for learning words,
made by Gerd Arntz for his son Peter, early 1930s.

SEIDENRAUPE

Seidenraupe

ZUCKERHUT

Zuckerhut

MAUER

Mauer

CHINESE

Chinese

Covers for Statistical Pocket books published by
the Central Bureau for Statistics and designed
by Gerd Arntz, 1956, 1957.

CENTRAAL BUREAU VOOR DE STATISTIEK

Statistisch zakboek

1956

Verkeersintensiteit op de Rijkswegen

1938/1939

1956

UITGEVERSMAATSCHAPPIJ W. DE HAAN N.V. UTRECHT 1956

CENTRAAL BUREAU VOOR DE STATISTIEK

Statistisch zakboek

1957

Bevolking van Nederland

1857

1907

1957

UITGEVERSMAATSCHAPPIJ W. DE HAAN N.V., ZEIST 1957

Covers for Statistical Pocket books published by
the Central Bureau for Statistics and designed
by Gerd Arntz, 1959, 1961.

CENTRAAL BUREAU VOOR DE STATISTIEK

STATISTISCH ZAKBOEK

1959

Zomerse dagen en ijsdagen
te De Bilt

19 55

19 56

19 57

19 58

Elk vakje stelt 5 dagen voor

UITGEVERSMAATSCHAPPIJ W. DE HAAN N.V., ZEIST

CENTRAAL BUREAU VOOR DE STATISTIEK

Statistisch zakboek

1961

Relatieve toeneming van employé's en arbeiders

1947

toeneming tot
1960

UITGEVERSMAATSCHAPPIJ
W. DE HAAN N.V., ZEIST

Landelijke bedrijfsorganisatie collectieve sector
aangesloten bij het OVB

Informatiebrochure

Landelijke bedrijfsorganisatie collectieve s
aangesloten bij he

Manifest
Statuten
Stakingsregle

De Boer Op

Jan Teeteruw / Walter Zegveld

MORGEN
BRENGEN

OVER INDUSTRIE EN WERKGELEGENHEID IN DE JAREN TACHTIG

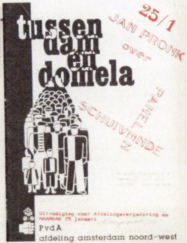

tussen
dam
en
domela

25/1
JAN PRONK
over
PANELN
SCHUIVENDE

Uitnodiging voor Afdelingsvergadering op
MAANDAG 25 januari

PvdA
afdeling amsterdam noord-west

Ist der 3. Weltkrieg
noch zu verhindern?

Beiträge zu einer notwendigen Diskussion

M. Massarrat • U. Albrecht
K. Mellenthin • K.H. Roth • J.P. Vigier
H. Birckenbach • P.K. Kelly
K. Coates • W. v. Bredow • B.C. Hesslein

Friedens- und Abrüstungsappelle

OVB & NVDU, leden
P·P·V·N·D·A
STATEN HER AKTIED
7e Jaargang
1979 SEPTEMBER 6
ACHTERBAN
terban vernieuwu
ialisten & volksgebou
sverniewing & jeugdra

EVELYN WAUGH

EEN HANDVOL
STOF

Assorted symbols and illustrations by Gerd Arntz,
re-used by other designers for covers of pamphlets,
brochures and books.

Gerd Arntz in his home in The Hague, 1981.

inspired by gerd arntz

The work of Gerd Arntz and Otto Neurath in developing the Isotype system and the stylistic guidelines for designing pictograms that accompanied it have had a lasting effect on graphic and information design world-wide. That is why we invited six graphic designers and one art historian to add a personal note to this book and state how Gerd Arntz's work and the legacy of Isotype has influenced them. They reflect on Arntz's importance for developing a veritable pictogrammatic or infographic language, the truly innovative character of Isotype, the re-use of Arntz's imagery in their own work, the legacy of Arntz that is now in the archives of the Municipal Museum in The Hague, and the still urgent lessons of Arntz's and Neurath's work for designers of infographics. Or as Erik Spiekermann summarizes: "It only takes one little Isotype chart (–) to destroy the validity of most business graphics."

Paul Mijksenaar (1944)
Owner of Mijksenaar, based in Amsterdam and New York. A world-wide authority on wayfinding systems, which he developed for railway stations and airports including New York's JFK, LaGuardia and Newark, and Amsterdam's Schiphol.
> page 72-73

Mieke Gerritzen (1962)
Graphic designer and webdesign pioneer in the early 1990s, internationally known for her bold and pictogrammatic style.
From 2002-2008 dean of Sandberg Institute design department. Currently director of the Graphic Design Museum Breda.
> page 74-75

Gert Dumbar (1940)
Graphic designer, founder of Studio Dumbar in The Hague, 1977. *Éminence Grise* of Dutch Design. Presented a series of international disaster pictograms in 2007. Receiver of the BNO Piet Zwart Lifetime Achievement Award in 2009.
> page 76-77

Max Kisman (1953)
Graphic designer, illustrator, type designer and animator. A pioneer in early digital design in the mid-1980s. His 'pictogrammatic' style is related to Gerd Arntz's, to which he has made many references in his own designs.
> page 78-79

Contributors

Flip Bool (1947)
Senior Collections and Research, Dutch Photo Museum. Lector of Photography at AVK/St. Joost academy, Breda. Published *'Critical Graphics and Visual Statistics'* with Kees Broos, the first overview of Gerd Arntz's work, in 1976.
> page 80-81

Erik Spiekermann (1947)
One of Germany's most prolific typographers and designers. Co-founder of MetaDesign (1979) and FontShop (1989). Now merged with Dutch design firm Eden as Eden-spiekermann. His writings are an incessant source of entertainment and design insight.
> page 82-83

Nigel Holmes (1942)
USA based creator of graphics, illustrations and animations that try to explain things. Set an international benchmark for information graphics with his work for Time Magazine (1978-1994). Author of *'Designer's Guide to Creating Charts and Diagrams'*, 1984.
> page 84-99

Gerd Arntz
Creator of a truly hieroglyphic 'Visual Esperanto for Workers'

by Paul Mijksenaar

Without realizing it, many a designer of visual information is in great debt to Gerd Arntz. The Lovely Language exhibition and the beautiful website gerdarntz.org, both initiated by Ontwerpwerk, have led even more designers to discover his pictorial strength and inspirational ideas.
The recognition for Arntz's brilliant designs, however, has somehow caused many to lose sight of his original goal, i.e. developing a veritable pictogrammatic or infographic language. What remains of his original intentions are a series of distinct picto-grams visualized through the 'freezing' of certain subjects. Among these, the slightly crooked figure of the 'unemployed man' remains an absolute favorite of mine.

Strangely, though, it is this isolated quality of Arntz's work that is his most important legacy. Not much is left of the pictogrammatic language originally aimed for by Otto Neurath – the man who commissioned Arntz to design it – other than the occasional 'infographics' in newspapers and magazines. And there's certainly not much left of Arntz's and Neurath's goal to use a pictogrammatic language for explaining the workings of the world's economy to an illiterate labor class.

This ideal, to develop a universal pictorial language, isn't that far removed from the Esperanto language invented some fifty years earlier (1887) by doctor Lezjer Zamenhof ('Dr. Esperanto'), an idea which also suffered an early death, caused by a perhaps similarly overconfident idealism.

Yet remarkably enough, around 1960 the idea of a universal language consisting of a series of pictograms was revived, this time at the hand of manufacturers of products like domestic appliances, cars, and hi-fi, in order to ensure a more low-cost production: by applying these product symbols they managed to come up with a single world-wide standard for each of their products. Presenting the client with a Bible-sized multilingual product manual explaining all these pictograms was something the public had to put up with.

Because this system enabled manufacturers to produce their goods in greater quantities and therefore offer them at much lower prizes, one might say that somehow the working class indeed has benefited from this. Today, there's virtually no household without a car, television, dvd recorder, or mobile phone, with all of these products demanding us to learn – through trial and error, or in a subconscious way – a new and rich vocabulary of universal symbols.

GERD A
1900-1988

Gerd Arntz's symbol for 'unemployed' in the exhibition
Lovely Language, Centraal Museum Utrecht, 2007.

Gerd Arntz
Head, Heart and Hand
by Gert Dumbar

Modernism captivated my attention at a very early stage. As a boy of not yet sixteen, I visited a Mondriaan retrospective in The Hague's Municipal Museum. It was then and there that my interest in the avant-garde of the 20th century was born, an interest that hasn't faded since.

This fascination was boosted considerably during my graphic design studies at the Royal Academy of Visual Arts in The Hague, where I engaged in long conversations with Paul Schuitema, whose progressive ideas and passion I greatly admired. There he would enthrall me with stories about his design practice, especially those of the 1920s. I subsequently continued my training at The Royal College of Art in London, where Anthony Froshaug would play a crucial role in my development as a designer. For this impassioned graphic designer was a modernist pur sang, a man whose work was methodical and intuitive alike. He had become friends with Kurt Schwitters, who died in 1948 in England. When I arrived in London, Froshaug had just returned from a teaching stay at the Ulm Hochschule für Gestaltung. The post-war continuation of Bauhaus, this institute was known for its systematic strictness.

During my studies at the Royal College of Art I became intrigued by pictograms, in those days a pictorial language only familiar to a handful of insiders. And it was Froshaug who introduced me to the work of Otto Neurath and Gerd Arntz.

Back in The Hague, I began to study Arntz's ideas and graphic work. The things he had thought up and developed during his stay in The Hague, in collaboration with Otto Neurath, filled me with profound admiration. Before me lay the body of work of two individuals we can call, without any hesitation, true innovators. Individuals who in their work tried to tangibly influence the political and social affairs of their day, as well as to contribute something useful to the world through their skills. As for me, I came to the conclusion that the pictorial language developed by Gerd Arntz could easily fill in where our written language fails to deliver. What surprised me furthermore was the fact that Arntz's original designs showed such stylistic durability. Oddly enough, their pictorial power sometimes reminded me of Walt Disney's very first Micky Mouse animations, dating from roughly the same period, i.e. the Interbellum years. (Needless to say there was a wide gap between the idealistic Arntz and the commercially astute Disney.) Many years later, I contacted Gerd Arntz in The Hague. There we would drink our tea while I would listen to his stories, absorbing his ideas and design experiences. At that time neither of us could foresee that one day we would work together.

Still, that's what happened: around 1980, Studio Dumbar was asked to design a corporate identity for the new Westeinde Hospital in The Hague. Part of the project was the demand for a simple and readable signage system for the new building. The design team was directed by Binnert Schröder, son of Truus Schröder-Schräder, the woman who, in 1923, commissioned architect Gerrit Rietveld to build the now world-famous Schröder House in Utrecht. Creating the signage system involved the design of an entire series of medical pictograms, a task which in my opinion called for a 'mobilization' of modernism. We invited Gerd Arntz to look over our shoulders as we worked on the project. I still keenly remember the constructive debates which he and our group engaged in, leaving us impressed with his critical and well-aimed remarks. Conversely, Gerd showed himself fascinated by the way we

field-tested our sketches, presenting them to medical doctors, nursing staff, and both Dutch and foreign patients and visitors at Westeinde Hospital. Gerd was thoroughly enjoying himself, as did we.

Until this very day these pictograms are being used. Quite in Gerd Arntz's spirit, Studio Dumbar sold the application rights to Westeinde Hospital for just one guilder, with the stipulation that third parties would have access to them for the same amount. And so it happened: the pictogram series was applied in both a French and a Brazilian hospital.

One last observation. At a certain point, being part of the Amsterdam Visual Arts Foundation's Graphic Design Commission, I was confronted with the question 'Who would be eligible for the Hendrik Werkman Award?'

I had little trouble in convincing the commission's other members that Gerd Arntz would indeed be a worthy candidate. After all, Gerd should have received the award many years earlier.

It was through Gerd that I also got acquainted with the ideas of Otto Neurath, the Viennese philosopher who fled the Nazi regime in his native country and died in 1945 in Oxford. A principled opponent of unshakeable rules and immovable methods, Neurath was a fervent proponent of common sense, skill, mutual understanding, and, in the end, of deciding and acting upon ones beliefs – all basic principles that have played an important role during the rest of my life. It was Neurath who once stated the phrase: 'Words divide, images unite'.

Gerd Arntz receives the H. N. Werkman Prize, 1985.
Left: Gert Dumbar and Gerd Arntz
Right: Jurriaan Schrofer

GERD ARNTZ
Barnsteenhorst 328
2592 ER DEN HAAG
Holland

31.8.87

Geachte heer Kisman,

Uw brief van 21 aug. bracht mij een beetje in
verlegenheid. Uw interesse in mijn werk doet
mij natuurlijk goed, maar wat kiezen?
Een "mijlpaal" was voor mij het uitbrengen van
"Gesellschaft und Wirtschaft" in Wenen 1930
Maar de afbeelding op de doos van de "Atlas"
was in veel kleuren (31 x 47 cm). Wij werden
beraden door Jan Tschichold en gebruikten de
Futura van Renner voor het eerst.
De gekleurde statistiek is uit "The Way Ahead",
Export-tijdschrift na de oorlog.
De derde afbeelding is ook typisch voor de
werkzaamheden van de Ned. Stichting v. Statistiek
Mag ik ev. keuze aan U overlaten?
Als U niet tot een reproductie wilt besluiten
ben ik geheel niet boos.
Omdat ik kort voor een ~~ei~~ openthoud op het
land sta heb ik jammer genoeg geen tijd om
meer in mijn documentatie te duiken, ook het
Haagse Gemeente Museum is goed er mee voorzien.
Veel succes wensend met "Typ"
vriendelijk groetend
G. Arntz

PRODUKTIONSFORMEN
GESELLSCHAFTSORDNUNGEN
KULTURSTUFEN
LEBENSHALTUNGEN

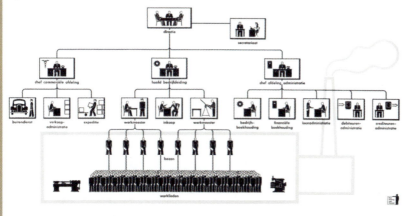

Letter from Gerd Arntz to Max Kisman (1987).

I asked Gerd Arntz to design the centerfold pages for TYP/ Typografisch Papier magazine #C, fall 1987. He mailed a few samples of his work. In his letter he mentions the publication of "Gesellschaft und Wirtschaft" (1930), in which he first used Renner's Futura, as a milestone. He also recalls a visit by Jan Tschichold and sends two other pieces, the colored statistics in export magazine "The Way Ahead", and a typical chart he made for the Dutch Foundation for Statistics. But the images didn't match the idea for the center fold, and we didn't use them.

inspired by gerd arntz

Gerd Arntz
A few recollections

by Flip Bool

For Peter Arntz (1924-2009)

The relationship between Gerd Arntz and The Hague's Municipal Museum goes back much further than many realize. Already five years before Arntz saw himself forced, due to the rise of national socialism, to move from Vienna to The Hague, the Municipal Museum acquired two of his woodcuts at the Amsterdam Stedelijk Museum's epoch-making 1929 exhibition *Architectuur, Schilderwerk, Beeldhouwwerk* (*Architecture, Painting, Sculpture*). The woodcuts were *Strandbad* (*A Bath at the Beach*, 1925) and *Bürgerkrieg* (*Civil War*, 1928); Arntz started working on the latter in Düsseldorf, completing it in Vienna, where Dr. Otto Neurath hired him, in the fall of 1928, as head of the graphic design department at the Gesellschafts- und Wirtschaftsmuseum, first as a probationer, then with a definite contract. Counting an additional work acquired through the municipal art budget – a 1968 linocut – the collection of Arntz's works in the Municipal Museum wouldn't grow beyond these three prints for the next four decades – in spite of the fact that Arntz resided in The Hague since 1934 and could by then be considered a truly Hague artist. Shortly before I started working as a graduate staff member for the print room in late 1974, Kees Broos published an interview with Arntz in the magazine *Museumjournaal* (Vol. 18, Nr. 5, pp. 207-209), on the occasion of the exhibition *Konfrontatie 2 – Sander en Diepraam*, in Eindhoven's Municipal Van Abbemuseum. Both Arntz and August Sander were part of the artists' group

'Kölner Progressiven' (Cologne Progressives), who championed a figurative constructivist style influenced by anarchism; the group was led by Franz W. Seiwert, editor of the magazine a bis z (1929-1933). A photographer, Sander gained world fame with his book *Antlitz der Zeit. Sechzig Aufnahmen deutscher Menschen des 20. Jahrhunderts* (*Face of Our Time. Sixty Shots of Twentieth-Century Germans*) (1930), the first volume of a publishing project showing a total of 552 portraits of human types, classified in 46 portfolios, meant to present a photographic and sociologic reflection of German society. Gerd Arntz and his wife Agnes were among Sander's artist friends photographed for the project.

Kees Broos' interview with Arntz on Sander quickly led to the plan to mount a retrospective of his work, in 1976 in The Hague's Municipal Museum – partly also because Nijmegen-based editor SUN had published a book about his work, in 1973, titled *Gerd Arntz. Politieke prenten tussen twee oorlogen* (*Gerd Arntz. Political Prints between two World Wars*). During my first period at the Municipal Museum, I visited Arntz almost every week while preparing for the exhibition. Gradually, the two of us developed a friendly relationship, not only based on my respect for his graphic work but also because Arntz was a captivating person and a man of wide reading.

His birthday, December 11th, happened to coincide with that of Kees Broos', and until Gerd's unexpected demise in 1988 we always celebrated them together, mostly in the company of a small circle of relatives as well as friends with whom he had collaborated at one time or another.

Although our interest initially focused on his creative art, with time it became clear that the greatest significance of Arntz's work would lie in his applications of the 'Viennese Method of Visual Statistics' as developed by Otto Neurath. The method's goal was to create a visual language in order to make relevant statistical information available

to the broader public, by using instantly recognizable, standardized symbols representing numbers. In light of the figurative constructivist formal idiom which Arntz had developed in his graphic work, he would turn out to be the right man to develop these symbols. Working as a graphic designer in Vienna, Moscow and The Hague, Arntz would make a vital contribution to the development of the pictograms that guide people in today's increasingly globalized world. Coinciding with Arntz's retrospective exhibition, the Municipal Museum acquired short of a hundred of his woodcuts and linocuts, as well as one of his few remaining paintings. A 1982 grant by Gerd Arntz enabled the museum to present a comprehensive collection containing almost all of his graphic works. No less important, and maybe more so, is the fact that this collection included his works in visual statistics. Searching for traces of Arntz's endeavors in this field, we discovered, in the basement of the Dutch Foundation for Statistics at Banka Square in The Hague, a couple of drawers containing more than 4000 symbols, as well as a series of files in which their applications in visual statistics were ordered. Put into storage at Arntz's retirement in 1965, these unique documents were in danger to be trashed at some point. Since their cultural and historical value was obvious to me, I contacted Louis Wijsenbeek, at that time the Municipal Museum's director, hoping he too would see the importance of Arntz's work in visual statistics and would be able to secure its future through a trust loan. Being centre-right oriented, Wijsenbeek however wasn't particularly pleased with Arntz's radical left-wing views nor interested in his work. Luckily, Wijsenbeek's son Siep happened to have played a major role in the introduction of the Dutch Railways' new corporate identity and pictograms, created by Tel Design. At a summer lunch featuring Russian omelets, at what was then Paviljoen Rigter, situated in the gardens of the Municipal Museum, father and son Wijsenbeek found the right ambience to strike a deal on the desired trust loan. Consequently, Arntz's 'applied' work in visual statistics was given considerable space at his 1976 retrospective, as well as at a small, additional exhibition in the main hall of The Hague Central railway station (see: *Telwerk*, Nr. 14). Since then, however, interest in his work seemed to wane, only to revive in recent times, with, among other initiatives, the *After Neurath* project by Stroom, in 2008, and a website (www.gerdarntz.org) launched by Ed Annink presenting a selection of Arntz's visual statistics symbols. Gerd Arntz's legacy is still alive and kicking, also on the international stage, as witnessed not only by the pictograms that each day show us the way around public spaces, but also in printed matter such as the wonderful booklet *Ost trifft West*, published in 2007 by designer Yang Liu (Verlag Hermann Schmidt, Mainz) and presenting different views and manners in both China and Germany. Without Arntz having lead the way, such a publication would never have been possible.

Otto Neurath once stated: "Words divide, pictures unite." It was Gerd Arntz who with great mastery translated these words into black and white, earning himself a permanent place in art history as one of the pioneers of visual communication.

Great War 1914-1918
Published in a traveling, folding presentation portfolio
for the Mundanaeum in London, 1930s.

Isotype the
transformers

by Erik Spiekermann

Like journalists who take facts and prepare them for their readerships, designers have always been transformers. Whatever we do to the information we shape, we influence its reception by transforming it. That goes for advertising as much as it does for hard-core information graphics. Tools are available to turn any dumb number into an equally dumb graphic, with multicolored gradations, drop shadows and pseudo-dimensional distortion. To paraphrase Churchill, 'there are lies, dumb lies, and there are Powerpoint presentations'. But it only takes one little Isotype chart, called "Comparisons of Quantities" to destroy the validity of most business graphics. It is a simple chart that shows how only one variable may look cool and simple, but to really compare things we need to show the method behind a graphic: how did we arrive at the numbers, what do they relate to and how do they relate to each other? One chart that displays all the qualities of the Isotype method is "Great War 1914–18" that shows how many soldiers were involved,

killed or wounded in the First World War. The illustrations are detailed enough to show differences in the uniforms but simple enough to be able to work even when reproduced at the size of a business card (the original was 420 x 630 mm). By showing the armies in parallel projection, marching away from each other, rather than as plain rows of soldiers like bars in a graph, it clearly distinguishes between the Central Powers and the Allies. This is reminiscent of old engravings with their isometric depiction of battle formations, but much more sober and dramatic at the same time. The chart can be read in three ways: comparisons between the sizes of the opposing whole groups; proportions within each group; between proportions of the same class across the two groups. One can almost understand the point most Isotype charts make intuitively, before even reading any detail. The facts are all there, but they have been transformed into communication.

Comparison of forms: squares, circles, rectangles and signs. Published in International Picture Language, Otto Neurath, 1936.
A small error in the last sentence, corrected by an attentive reader; 2 is 1/3 of 6.

Great War 1914-18

Each figure 1 million soldiers
(killed, wounded, others returning home)

Central Powers
Germany, Austria-Hungary, Bulgaria, Turkey

Allies
USA., British Empire, France, Belgium,
Italy, Serbia, Rumania, Russia, Japan a. s. o.

ISOTYPE

Squares
One is only able to say :
2 is greater than 1
B is greater than A

Circles
One is only able to say :
2 is greater than 1
A is $^{6}/_{10}$ of 1
B is $^{4}/_{10}$ of 2

*Four-sided forms put
together from units*
One is now able to say :
2 is twice as great as 1
A is $^{3}/_{5}$ of 1
B is $^{2}/_{5}$ of 2
A is $^{3}/_{4}$ of B

Groups of signs
One is able to say :
Group 2 is twice as great as group 1
Number of men is $^{3}/_{5}$ of 1
 (number of women $^{2}/_{5}$ of 1)
Number of men is $^{3}/_{5}$ of 2
 (number of women $^{2}/_{5}$ of 2)
Number of men in 1 is $^{3}/_{4}$ of number of men
in 2
Number of women in 1 is $^{1}/_{2}$ of number of
women in 2

96

PICTURE 35

D

inspired by gerd arntz

the following pages are contributed and designed by nigel holmes
the text was previously published in *information design journal 10 (2)*,
pp. 133-143 (2000/2001)

Erin and I cycling. It's based on an icon of a man on a
bike by Gerd Arntz, which he drew while he was working
with Otto Neurath in the 1930s. In 2002, I modified his
beautifully simple image and included it as a very small
part of an explanation graphic in Attaché, USAir's
in-flight magazine. (Here it's greatly enlarged.)
Am I stealing Arntz's work? I hope it's seen more as
an homage to him. I have tremendous respect for his
work, and I'd like to think that this essay might help
others appreciate his influence on aspects of current
graphic design.

Pictograms:
a view from the drawing board, or, what I learned from Otto Neurath and Gerd Arntz (and jazz)

by Nigel Holmes

Sports icons for *Radio Times*, The British broadcasting corporation, London, 1969-78

Introduction

The first pictorial symbols I drew were for the Radio Times, the TV and radio program guide of the BBC in England. From 1969 to 1978, I did about 200 such symbols. They alerted readers to programs (usually live sports broadcasts) that would be continuing over a period of days. Don't forget that some cricket matches in England last five days (!), and then there's always Wimbledon and show jumping, and endless coverage of soccer, golf and the summer and winter Olympics.

Each year, David Driver, the art editor of Radio Times, commissioned me to do a set of sports icons that was different from the previous year's set — just the way host countries commission their own custom set of Olympic Games icons every four years.

35 years later, I still love making these tiny images. For instance, to bring a formal unity to many different categories in a new edition of the Mexican Yellow Pages, these icons were part of a set for the listings.

Icon set for the Mexican Yellow Pages, 2001

Apart from sets of icons (like the ones for the yellow pages), there's another role for these minute pictures: icons which are part of larger diagrams. When I started to look back at my own work, I found hundreds of little drawings embedded in my work (→), and I think that most information/explanation designers have drawn (or used) icons like this without even thinking about it. We regularly substitute icons for certain words or ideas (↘). When Otto Neurath called his International System of Typographic Picture Education (Isotype) a "helping language" (rather than a complete visual substitute for a written language), he was suggesting what today is taken for granted in this field: words and pictures *together* make better explanations than words alone, or pictures alone.

Despite some references to, or even emphasis on the work of Otto Neurath, his wife Marie, and their star artist/designer Gerd Arntz, this essay does not set out to be an historical review of pictogram design; it is not comprehensive about the subject, nor even particularly impartial. It is one artist's thoughts about pictograms, icons and symbols*, and the process of making them.

I listen to jazz (not while drawing, it's too distracting), and I'm not the first to note some parallels between the creation of jazz and the creation of images. From time to time here I'll include an observation about jazz that might help readers understand some of the points I'm trying to make about drawing pictorial symbols.

Components of many explanations, 1987-2003

When icons stand in for words
I think I'll go to the bathroom!

* I'm using the terms pictograms, icons, and symbols to mean the same thing, but I am aware that academics and word nerds love to go on about the differences between them.

Lillehammer
1994

Albertville
1992

Innsbruck
1976

Round, *Money* magazine, 1997

Square, CNF transportation, 2002

Implied square, *Outdoor Explorer*, 1999

Diamond shaped, millennium poster,
The Associated Press, 2000

Art, mechanics and the market

When drawing pictograms, I try to find a balance between drawing in its freest sense (hand-on-paper) and the more mechanical means of producing marks (either hand-on-paper with a french curve or ruler; or hand-on-mouse); between a human approach and a robotically systematic one; between wiggly lines and straight lines; between the Lillehammer and Albertville Winter Olympics symbols on the one hand, and the gridded, Aicher-inspired organization of the Innsbruck Winter Olympics symbols on the other. (←)

Designing individual icons to be part of a complete set presents an additional challenge, because sometimes icons that represent *objects* are part of a set that includes icons representing *actions*. Formal conventions will help make a group of symbols appear as a cohesive set. Among them are:

☞ **the** overall shape, **including: round (←), square (←), implied square (←), diamond shaped (←)**

☞ **the** style of the drawings, **including: continuous single line (→p.88), white line on a black background (→p.89)**

☞ **the** subject matter, **for instance: animals (→p.89), children (→p.89)**

☞ **the** context **in which they are seen: Olympic Games, zoos, washing machines, car dashboards**

☞ color coding

Icons and signs for an event like the Olympics employ all of these conventions at the same time.

In addition to artistic considerations (how do I get the images down on paper?), there are commercial considerations—usually there's a brief involved, and with that comes an art director and a client who probably have their own ideas about the look or feel of the icons they are commissioning. They might want a "modern look," or a "retro look," or a "metallic look"—not the kind of direction that I like to have, but understandable today when companies are trying to differentiate themselves from one another.

Marie Neurath and others have proposed that certain pictorial symbols should be agreed upon and then left unchanged, making a kind of universal language. That could have advantages in such places as airports*, but I think there should be individual visual languages, just as I would preserve foreign spoken and written languages.

Actually, the more icons I do, the more I find I am establishing a personal visual vocabulary, and that I can use it in widely different applications for different clients. However, clients generally want every item they commission to be new and custom-built for them—images they can call their own. We all have to compromise. And thus the Babel of visual symbols grows.

*The world's airports may in fact be moving toward some standardization of icons—at least of wayfinding icons. The Dutch designer Paul Mijksenaar is leading the field in helping travelers find their way around more efficiently. You can see his clear, simply color-coded work in action at JFK Airport in New York, and at Schiphol Airport in Amsterdam, among others.

Continuous line (mostly), *Network World*, 2002
This is a selection (from a set of 50) that was intended to be a kit of parts for the many information graphics that the magazine produces weekly. This set would allow any of the graphic designers at the magazine to build graphics that all came from the same "family".

White lines in a circle, Smithsonian Institute, 2002

Animals, the *Time* education program, 1996

Children growing up, *Understanding children*, 2002

Here's a jazz comparison about having to do things the way other people want you to. When the trumpeter Louis Armstrong first joined King Oliver's band in Chicago, he was already well-known for his extraordinary talent. But Armstrong had to tone down his distinctive "voice" because there could only be one leader in Oliver's band—that was Oliver himself, and he played the trumpet too. Only when Armstrong left to form his own band was he able to design music that he could call his own.

This is not to say that making music is the product of one person operating alone—it's a collaboration. Jazz, especially small group jazz, depends on the interaction of the players, each listening carefully to the other and responding to the sounds. It's just that commercial considerations in music (and designing) often get in the way of what a musician or designer wants to do, even what they think is really the right thing to do.

The following factors swirl around in the mind of a designer working on an icon or a set of icons:

☞ the act (and art) of drawing versus making a mechanical product

☞ a systematic approach that binds a set of icons together versus the freedom to do effective individual icons. (There always seems to be one in a set that doesn't fit the overall pattern!)

☞ the constraints of the marketplace versus doing what might be personally more interesting (using your own "voice")

inspired by gerd arntz

A word about style

Designers and artists are often criticized for looking at the surface appearance of other designers' work. Arntz's drawings have a particular look, and it is one that's easy to imitate. But Neurath's Isotype system of charting statistics is much more than a dictionary of visual symbols. The system has strict principles concerning how to arrange the pictorial icons into charts. For instance, they are almost always lined up horizontally, rarely stacked vertically. This example (with my icons) is how an Isotype chart would appear (↓).

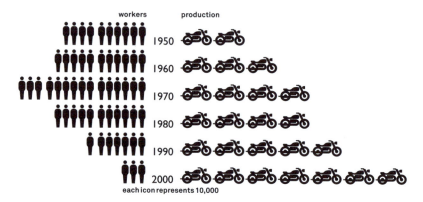

each icon represents 10,000

Neurath's method allows you both to see the content and the trend of a chart, and also to count the numbers. He called this "statistical accountability". See below for a fuller definition.

While Neurath knew the value of pictures as a way to get people interested in what he was showing them, he was also aware of the charting pitfalls that went with pictures (→). To avoid these pitfalls, he developed what he called "statistical accountability." He and Arntz designed icons that could be used next to one another in rows. They could stand for quantities and thus be "account-able." The spacing between these "characters" was critical so that a naturally narrow object (a herring) could be seen to have the same visual weight as a naturally fat object (a barrel) (↓).

The wrong way: if you just enlarge the image, the numbers are badly mispresented

each icon represents 10,000 marriages

Neurath's way with the same numbers as above

How to make herrings appear as "fat" as a barrel

In 1979, Arntz published a collection of his icons from various times in his career, in a kind of visual dictionary, and this may have muddied some of the purity of Neurath's ideas about how icons should be used. Likewise, Rudolf Modley's *Handbook of Pictorial Symbols** is a nice cheat-sheet of easy-to-copy images, and although it does include a brief explanation of the systematic thinking behind the use of icons, the title clearly states the intention of the book.

Nevertheless, Arntz made wonderful drawings, and they remain great lessons in how to draw pictograms. While some of the images may look dated (cars, telephones), his drawings of people are amazingly expressive, although made with very few marks (←). Arntz was an artist first, and a designer second. Neurath recognized that Arntz's talent for capturing the essence of an object or a person with such economy of form could help his effort to explain things to readers with the help of an iconic picture language.

Artists look at surface style and want to imitate it—we learn that way. I daresay that Arntz had a good look at Egyptian hieroglyphs without necessarily understanding all the meanings. Most art comes from other art: it's a reaction, a development, an improvement. Whether we like it or not, we are influenced by what we can see, long before we understand what it means. There's nothing wrong with that.

But when designers imitate the look of an Isotype chart, while ignoring the underlying "system," the resulting graphics may have only the "feel" of information design.

*Modley, an American, worked with Neurath in Vienna from 1923 to 1930.

They are not necessarily informing us at all. I suppose the result is a sort of salute to the visual language that Neurath and Arntz developed, but designers today who don't follow Isotype principles aren't really using the language in a way that communicates with readers.

And it's the same thing in jazz. When saxophone players—that is, those who wanted to be part of the bebop scene in 1945—first heard Charlie Parker's sound, they all wanted to play exactly like him. In fact they felt it was the *only* way to play.

Parker (→) showed jazz musicians what bebop was supposed to "sound" like. But copying the sound was not enough. (If you simply copy the sound or the appearance of what somebody else does, the result will probably be very shallow.) Musicians had to understand the principles behind Parker's work in order to take their music to the next step—being able to make their "own" sound. We designers can signal "information design" by the surface appearance of our work, but we must deliver the information too. Otherwise, we can rightly be criticized for publishing meaning-less "datajunk." I've had some academic tomatoes thrown at me in the past.

Charlie Parker (sometimes I just want a break from mechanical drawing). Pencil drawing based on a late 40s photo from *The Record Changer*. I used this as part pf an explanation of how a saxophone works in *Attaché*. 1998.

How to draw: three approaches

1. Geons
Cognitive scientists have tried to explain what's going on in our heads when we look at things. One theory posits that there is a set of shapes stored in the brain which we refer to whenever we look at an object. In a flash, we unconsciously compare the overall shape of the seen object with a checklist of component shapes already in our brains.

More about geons in my little book *Drawing to explain*

Geons: shapes "stored" in the brain

Taking a line
for a walk
(around an
object)

Parts of an iconic
microscope

Line-for-a-walk
microscope

Geon microscope

Line-for-a-walk car... ...filled in

Showing the wheels makes the car more "carlike"
You can always adjust little details like the windshield later.

Geons are great for making icons that will be reproduced very small;
you are forced to reduce everything to the most basic shapes that will
still "read" at a tiny size.

When we put the shapes together,
we recognize what we are looking at.
The scientists David Marr and Irv Biederman
call these component shapes "geons". Their
theory of how we recognize things corre-
sponds with one way that artists are taught
to draw: break down the thing in front of you
into basic shapes, and build a drawing from
those shapes.

This is a good way to approach drawing
symbols—in contrast to Paul Klee's
definition of drawing as "taking a line for
a walk." In this scribble of a microscope (←),
a line has been traced—or taken for a walk
—around it. If, instead of doing this,
you construct the image by using building
blocks (geons), you'll start to think about
what the object is, rather than what it looks
like. So you won't be drawing what you see,
but rather what you know about an object.
You could break a microscope down to five
geons (←). When these shapes are fitted
together they make a "better" icon of
a microscope than one made by a line
wandering around its edges (←). Incidentally,
this icon even begins to suggest how the
real microscope fits together, because
the geons represent not only the look of the
thing but also its mechanical components.

If you take a line for a walk around a car,
the wheels appear as blobs sticking out at
the bottom (←). It's not a bad icon, but try
building the image from basic shapes.
You'll emphasize the function of the wheels
(←), and suggest an essential part of a car,
the motion.

Beware of putting in too much detail. If you
know what an object looks like, it's often
better not to use visual reference, such as
a photo, but rather just to think about what
you are drawing. This way you can get at the
essence of the thing—either its function or
its appearance. Of course if you really don't

inspired by gerd arntz

know what a kangaroo or a cello looks like, find a picture. But then when you start to draw, set the reference aside and use simple shapes to make your iconic version of them.

2. Silhouettes

There is something about the silhouette that has a dispassionate, scientific authority. The writer Ellen Lupton describes silhouettes as "a kind of pre-chemical photography… an indexical image made without human intervention, a natural cast, rather than a cultural interpretation." (→)

Snapshots of time
(traced from a series of photographs by Eadweard Muybridge)

Here's Neurath's practical advice about how to reduce the appearance of an object to its essence:

☞ use art materials that force you to simplify the marks you make. For instance, Neurath got his artists to cut images out of black paper.

☞ draw the object as a silhouette (→)

Silhouettes get at the essence of things

In other fields, designers face the same restrictions. The way neon signs are made, for instance, requires the designer to be simple. These examples are (→) a bit like the single-line icons on page 4.

NOVILUX

TYPES A (1.70 à 2 m. de tube) **Frs 650**
Quelques exemples:

Autres modèles :

Parapluie ouvert, Ciseaux, Gant, Poisson, Escargot, etc., etc.

Neon signs from a 1935 catalog

I try to find the most representative view of an object. Sometimes a side view is the best, sometimes a bird's-eye view, sometimes a front view. Occasionally, compromises are necessary. A true side-on view, or profile, of a pair of spectacles does not remind you of spectacles, it just looks like a letter j on its side (→).

Find the angle that best sums up the object

Art: what Arntz leaves out is just as important as what's there. Your eye fills in the missing pieces (redrawn).

What makes Arntz's work so interesting to artists is that it is warm and human, despite the impartial, scientific bent that Neurath wanted the Isotype system to have. Arntz's drawings were the most visible part of the system*, but were not the kind that one might have expected given Neurath's kit-of-parts approach to chartmaking. Note that what Arntz left out was as important as what he included. Jazz again: in contrast to Charlie Parker's torrent of musical notes, pianist Thelonius Monk created "an art of implication" (according to Lewis MacAdams in *Birth of the Cool*). Monk left spaces in his music, which the listener naturally filled in, just as we do when looking at a drawing by Arntz (←)

3. Observation
There are many ways to draw pictograms, and I'm not trying to impose hard and fast rules here. Drawing with geons is just one way. It's a right-brain, analytical approach. For a moment, I'll argue on behalf of the other side of my brain: the left, artistic side. (This is the balance I mentioned at the beginning of this essay.) For me, using geons at the start of a project does actually tend to make the finished work look a bit mechanical, although at times that can be OK, even desirable—see the microscope example on page 9. These "digital" office stationery icons were intentionally machine-like (←).

Intentionally mechanical

But at other times, when drawing humans, for instance, a less geometric approach seems to give better results. Arntz's work is a good example. Perhaps we see his influence in Keith Bright's symbols for the 1984 Los Angeles summer Olympics,

*In addition to Arntz, other artists worked with Neurath; among them were Augustin Tschinkel and Erwin Bernath.

as opposed to Otl Aicher's symbols drawn for the 1972 Munich Games (→). Bright softened the mechanical quality of Aicher's set by showing little bulges for muscles in the arms and legs.

To keep the balance between a geometric interpretation of an object or a person and a freer rendering, I'll often start with lots of tiny hand-drawn scribbles (↘), then apply geon/shape-thinking as a way to help me get to the essence of the object. The use of basic shapes pushes me towards a clear image. It is a bridge between my intuitive vision of something and a symbolic representation. Having a healthily split personality (a true mix of left- and right-brain attributes) is the best state of mind to be in when designing symbols: it's part art, part analysis.

First the mind and then the machine

Only when I have a good sketch of the image I want to end up with, will I start to use the computer—never before. "Drawing" with a computer is a very unnatural process, whatever claims the makers of popular drawing applications may make to the contrary. There is a particular look to computer-generated graphics, and you can tell when an artist has allowed the application to take over from his or her intentions. If we don't pay attention while using the computer, the result is obvious—it looks as though the machine has done the work, using the formulas already stored within it.
The trouble is, we may sometimes like what it produces, and be initially satisfied with it. We have then either been seduced by the machine's slick graphics application, or we're just lazy. It's wrong to think that computers will mask bad drawing—they just make bad drawing look slicker. I think that

Otl Aicher's Munich Olympics runner, 1972

Keith Bright's Los Angeles Olympics runner, 1984

Just for comparison: Masaru Katzumie's runner for the Tokyo Olympics, in 1964.
This is easily my favorite Olympics set.

Feeling your way to the right shapes by scribbling with a pencil...

...Helps you to formalize the finished drawing

Miles: a jazz icon

using the hand to sketch remains the foundation of this work. The proof is in the warm, human emotion you get when you see a beautifully produced symbol, however small it may be, and however much you take it for granted because it's just a traffic sign or a small part of a diagram. I'm not against computers—everything I do is eventually produced on the Mac. But I use the machine primarily to pare down an image; to find the most economical way to represent something; to take things away, rather than to build up an image by adding extraneous (and all-to-easily produced) effects. Listen to trumpeter Miles Davis's earlier work—that unmistakable, simple sound. His pared-down simplicity did not make the sound generic. You can feel the person behind the notes. Later in his career, he did turn to electronics, and in the process I think his trademark sound lost much of its personality.

Listeners are drawn to Davis's early work: spare, clear lines of melody, unfussy, and without the helter-skelter of notes that his fellow beboppers were playing at the time. In the same way, graphic symbols work best when they are simply conceived and executed (←). In both cases, there is human pleasure in recognizing elegant simplicity through economy of means.

Chaplin: a Hollywood icon

Door · Entrance · Exit · Fire Exit

Letter · Telegram · Wings · Air Letter

Semantography by Bliss, Australia, 1966

Happiness · Anger · Suffering Trouble

Rain · Sadness Sorrow Grief · Fall

Locos by Ota, Japan, 1971

The picture/word mix
There have been well-documented attempts to make self-sufficient visual languages—for instance Charles Bliss's Semantography (←), and Yukio Ota's LoCos (←). But while some airport and traffic sign systems aspire to form a wordless international language, most of the time (when it comes to explaining things, at least) it's a combination of pictures and words that work best.

Sometimes icons and symbols are used as tiny visual gifts in graphics: a little ☎ next to the phone number on business cards, or a symbolic eye next to a page number to denote "see page…" It can be fun too. I put a snail next to the mailing address on my business card. It's not necessary, but it matches up with the mouth (representing voicemail, or phone), the fax machine icon, and the computer icon for email and web addresses. Purists will note that "snailmail" is hardly international and could be meaningless to many people. Here's one place I'll let Neurath have his own opinion, and personally reserve judgement. He believed that a symbol should represent only what a thing looks like, not what the word for it sounds like, and it should never be a play on words. It was all part of his effort to help international understanding.

Business icons, 2001
Outside English-speaking countries, does a snail make sense?

Silence is golden, *successful meetings*, 2000
While most cellphone users round the world don't seem to value this old saying, they probably do recognize this iconography.

Now that the world is becoming one big, undifferentiated culture, a little movement in the other direction, towards preserving differences, might be a relief. I believe that it is rather exciting to be slightly baffled by foreign languages, because you learn something while you are figuring out the meaning. (Of course, I don't want to be baffled while rushing to catch a plane.) Does the hand sign shown here (→) mean the same thing all over the world? And should I worry about that when designing a logo for an Anglo/American company?

Pictorial logo for *Client FTP*, an internet service for delivering and approving digital files.

38%	37%	12%	8%	5%
4 hours of free time with spouse every week	$200 gift certificate to favorite	1 hour of free time a day	Help on weekends	2 hours extra sleep

Combining words and pictures: What mothers really want, *Parenting*, 1997

Large and small

With the exception of Gerd Arntz's work on pages 91 and 95, most of the examples I've used to illustrate this essay are about the size they were when they were originally printed. I work quite a bit larger than this when I'm making them, so that I can more easily see what I'm doing. But I have to remember that for all my talk about "art," these are works of commerce first and art second, and are seldom the visual stars of a printed page. They are supposed to be small (←).

But this is nearly my last example, so let's be indulgent. It is nice to see it big!

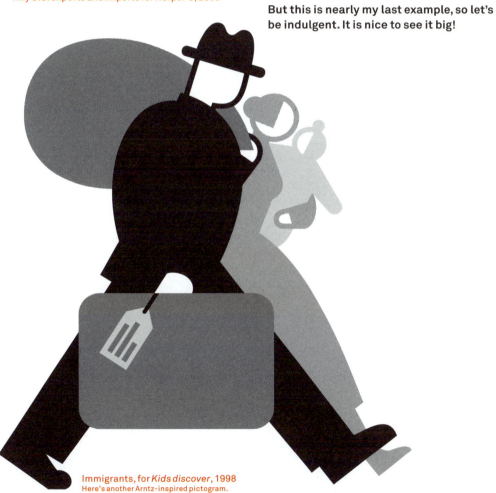

Tiny U.S. exports and imports for *Harper's*, 2000

Immigrants, for *Kids discover*, 1998
Here's another Arntz-inspired pictogram.

political prints

In his early twenties, the young German artist Gerd Arntz said goodbye to his bourgeois background and committed himself to the struggle of the underprivileged workers. During an artistic career spanning 50 years, he has continually criticized social inequality, exploitation and war in clear-cut prints – activism with artistic means. For the engaged artist Arntz, the wood-cut was the chosen medium, because of its 'primitive' aspect and its clear black-and-white contrast. In the 1930s, Arntz switched to linoleum-cuts. His prints were exhibited, sold to art lovers, and published in magazines of the activist left in Germany and abroad. The work for Otto Neurath provided him the means to continue his own artistic work, completely independent of the art market or political affiliations. His prints criticizing the capitalist system did, for instance, not prevent him from critically looking at the downside of the Soviet Union in other prints. Arntz continued cutting his social and political critique into linoleum until he was seventy years old.

At 25, Arntz depicts the division between rich (against a clear background) and poor (in a gloomy environment). With its four classes, the 'Mid-Europe' train symbolizes class society. The railway sign above the left carriage says 'stop here', while the sign on the right signals 'continue on'. This was one of Arntz's prints which Neurath saw in 1926, and which convinced him that this artist, with his trimmed down realism, was just the man for him.

| A | B |
| C | D |

| | E | F | |
| | G | H | |

Mitropa, 1925

woodcut 44,6 x 26,7 cm

All the 'figures' reproduced here – the trains, the luxury car, the pram, the characters and ciphers, the different human shapes – can be perceived, whether in strict frontality or in profile, as being separate signatures (hieroglyphs) that can be reused, re-produced, as such – they can be 'read' in an entirely different constellation of signs. (As indeed is the case with the pictograms). The organization of the elements into a cogent configuration no longer takes place by means of reproducing an illusory space – here, *only the signs*, not the space, refer to the concept of 'city'. Thus, the image is now being organized by using the formal means of the black-and-white picture itself: the alternating black and white, and the different axes that divide and at the same time unite the picture. Firstly, there are the vertical and horizontal axes, dividing the image in four rectangles of equal size: two predominantly black ones (fields A and D, above left and below right of the picture centre), and two predominantly white ones (fields B and C, above right and below left of centre). These 'colors' refer to a well-known reality of society: in the B and C fields, picturing the class of the bourgeoisie, light and open skies dominate, while the human figures enjoy plenty of room as well as the attributes of wealth (wine, a car, fur coats); on the A and D fields, the figures (workers, actually) stand tightly packed and can make limited use of cheap ways of transportation, et cetera. There are more axes: the superposed B and D fields are both separated evenly by a single large vertical axis, while on the left half of the picture only the A field is

treated this way. Thus, the C field, in the below left corner, is a large white field showing the two magnificent female figures (reminiscent of the whores of George Grosz [George Grosz, 1893-1959] whose physical forms are still discernable beneath their clothing). The A and C fields are also cut through, this time closer toward the main vertical axis, by an axis that runs parallel to it, thus creating the E and G fields, which each occupy a little less space than a third of, respectively, the A and C fields. The same thing occurs at the F and H fields with respect to B and D.

In this way an image is created which retains its optimal brightness and coherence while at the same time showing great complexity when analyzed more thoroughly. Obviously, these complexities bear on the general impression the image leaves – they make it exciting and surprising while referring to the fact that we are not merely dealing with a static picture but with *a movement that has only just been stopped*: the continuity of history has been breached to give way to a deeper understanding. An axis isn't merely a 'line'. For example, if one follows the main horizontal axis in the centre, at one moment one will see an individual black line, at another moment an individual white line. Yet above all one will encounter white and black fields bumping into each other, with the axis sometimes *dissolving* into the black and at other times into the white. (This principle, providing ever-new functions to elements which themselves are unchanged, permeates the entire image. Thus, in the D field, the figures have either been *drawn* in white on a black

background, and vice versa, or are *fields* of white surrounded by black, and vice versa.) This reveals itself even more clearly when one carefully follows the diagonal axis through the G field (a faint reference to the futuristic 'lines of force'): an anomaly within the strict horizontal and vertical grid, this axis is only counterbalanced by a few minor diagonal axes slicing through the fields around the train wheels as well as by the slashes in the D field. Again and again, the black-and-white alternation is focused around an axis, as is the case with the left wheel of the pram, its circle shape being either in black cutting through a white field, or in white cutting through a black field. In some cases the movement of the elements can even 'divert' axes from their strict and formal orientation: the axis slicing the cart wheel in the D field, below left, bends along with the cart's position.

From: *Gerd Arntz, Politieke prenten tussen twee oorlogen*. SUN (Nijmegen, 1973). Introduction: "On the artistic and political viewpoints of the Rhineland 'Progressives'" by Kees Vollemans.

Private house, 1927

woodcut 16,1 x 25,1 cm

In his series 'Twelve Houses of this Time' Gerd Arntz depicts
the very differing living conditions of the various classes.
The attics and basements were for the poor, while the rich
occupied the spacier, lighter and more easily accessible
apartments. The rich man in the middle has a mistress and a
maid and modern conveniences like water closet and shower,
where his upstairs neighbors only have a sink and a simple
stove and the crowded basement is lit by a mere candle.

Harbor strike, 1930

oil on canvas 80 x 120 cm

Protected by an intransigent policeman, the well-dressed passengers on the ship look towards the quayside with indignation and fear. The title explains their distress. This canvas is the second from a series of four, from which only this one and the fourth have survived. In total Arntz made fourteen paintings; only around half of them still exist.

Crisis, 1931

woodcut 21 x 30 cm

Gerd Arntz: 'In this print, the masses who can't buy anything are depicted on the lower right side. On top, left, are the representatives of agriculture and industry, who have allied with a clerk – identifiable by his wallet with an eagle on it. Although a neutral figure invites the masses to purchase, the poor can buy things only in their dreams. The dollar sign symbolizes the 'brake', the impossibility for them – unlike the rich – to acquire the goods.' *(Gerd Arntz. De tijd onder het mes)*

Unemployed, 1931

woodcut 21 x 30 cm

At the top, the rich cash their stock and entertain themselves with perversities or idleness, while the worker toils at the assembly line (centre) and the unemployed (below) are kept in check by the military. The 'little man' drawn by Arntz here returns in the visual statistics as the Isotype pictogram of the unemployed with his head between his shoulders and his hands in his pockets.

The Third Reich, 1934

woodcut 21 x 30 cm

The Führer at the top of the Nazi pyramid, consisting of usurious capitalists, the military, judges, concentration camps, the SS and SA and propagandist workers. Each has their own sign – the eye-glass for the high officer, the flat cap and strap for the SA. With just his moustache and slanted lock, Hitler has already become a logo. Gerd Arntz: 'The fact that the whole composition is a bit crooked, gives a 'falling' impression, is on purpose. The Third Reich wouldn't last very long, I thought then.'

(Gerd Arntz. De tijd onder het mes)

On the quay, 1935

woodcut 21 x 30 cm

Less directly political in nature, this woodcut still symbolizes
the distance between the classes. As in earlier prints by Arntz,
the rich and leisurely are on top and in a predominantly white
section, while the workers huddle at a lower level against a
dark background.

Candide, Chapter 21, 1947

linocut 24,4 x 16,3 cm

In the late 1940's Arntz took to illustrating classic works of literature like Ovid's 'Metamorphoses' and Voltaire's 'Candide'. The caption of this illustration quotes Candide, Chapter 21: "Do you think that mankind always massacred one another as they do now?" ... "Do you believe," said Martin, "that hawks have always been accustomed to eat pigeons when they came in their way?"

Gerd Arntz: 'I was interested in depicting flesh and blood and sensuality. Unlike my previous prints, I did not fit the figures into an architectural construction anymore, but grouped them as one seamless composition.' *(Gerd Arntz. De tijd onder het mes)*

Utopia?, 1969

linocut 42,1 x 48 cm

This is Arntz's last single print. It shows the hopefulness of
the youth after the Second World War. Arntz himself did not
have much faith in it, as is apparent from the construction of
the image as a house of cards, and the play with the French
word 'GREVE' (strike), which when someone blocks the 'G'
becomes 'REVE' (dream).

visual statistics

The International System Of TYpographic Picture Education (ISOTYPE) was developed by Otto Neurath as a method for visual statistics. Gerd Arntz was the designer tasked with making Isotype's charts, pictograms (*Signaturen*) and visual signs. Many of Neurath's contemporaries rendered proportions by varying the size of their symbols. But according to Neurath's Isotype rules, more or less are not represented by bigger or smaller symbols, but by more or less symbols, each symbol representing a specific amount. In this manner, relations can be read more easily and exactly. Apart from being an acronym, 'Isotype' is also Greek for 'the same sign'. By developing a standard for visually representing information, Neurath and Arntz changed a style of illustration into a coherent visual language for making 'visual texts'.
Presented on the following pages are several statistics from the atlas *Gesellschaft und Wirtschaft – Bildstatistisches Elementarwerk* (printed and published in Leipzig, 1930); statistics from the book *Modern man in the making* (New York, 1939); and charts made for various clients, such as the Dutch Central Bureau for Statistics.

Car ownership in the world

Published in *Gesellschaft und Wirtschaft*, 1930

Interesting in this graph from our perspective is that the steering wheels of Arntz's symbolized cars are on the right, and not on the left, as would be the case for the USA at least. In a large part of Austria, including Vienna, traffic was driving left at the time. After the Nazis took over Austria in 1938, this changed, and now also all of Europe, with the exception of the United Kingdom, drives at the right.

Commercial fleets of the world

Published in *Gesellschaft und Wirtschaft*, 1930

A parade of flags flying above though ships symbolizes the rampant growth of commercial shipping at a time when Great Britain still ruled the waves. The flags, with their recognizable forms and clear colors lend themselves well for rendering information in an 'isotypical' way.

Kraftwagenbestand der Erde

Anteil der U. S. A. Übrige Welt

1914

1920

1928

Jedes Auto 2 500 000 Kraftwagen

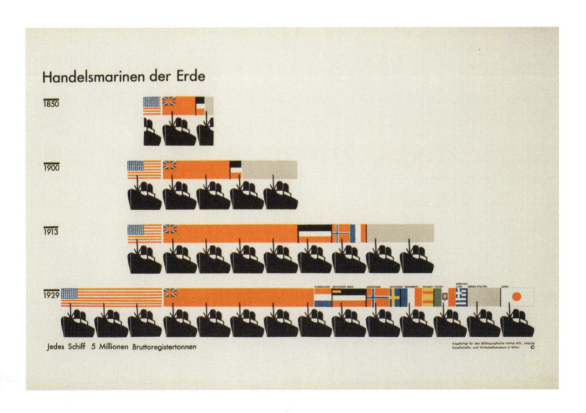

Handelsmarinen der Erde

1850

1900

1913

1929

Jedes Schiff 5 Millionen Bruttoregistertonnen

Unemployed

Published in *Gesellschaft und Wirtschaft*, 1930

As the icons for unemployed are rendered here, they conjure up the image of long queues in front of the welfare office. Remarkable in this chart is that in France there seems to be no unemployment since 1920. The reason for this could be lack of data, although this is not mentioned in the caption.

Arbeitslose

	GROSSBRITANNIEN	FRANKREICH	DEUTSCHES REICH

1913

1920

1925

1926

1927

1928

Jede Figur 250 000 Arbeitslose

Angefertigt für das Bibliographische Institut AG., Leipzig
Gesellschafts- und Wirtschaftsmuseum in Wien ©

New York

Published in *Gesellschaft und Wirtschaft*, 1930

The development of a world metropolis in a nutshell: from 25.000 inhabitants to 9.5 million within a century and a half. To go by the chart, Neurath has counted in New Jersey and other urban areas neighboring New York, because the official population of New York in 1930 was 6,930,000.

Strikes

Published in *Gesellschaft und Wirtschaft*, 1930

Against the background of abstracted factories, workers of all nations raise their fists united. This chart shows the vagaries of workers' unrest over several years in various countries.

New York

1767 Englischer Handelsplatz holländischen Ursprungs

1805 Beginn stärkerer Entwicklung

1930 Moderne Stadt

Verbaut Strassen u. Plätze Grünfläche
Unverbaut Eisenbahn Wasser

Jede Figur 100 000 Einwohner

Angefertigt für das Bibliographische Institut AG., Leipzig
Gesellschafts- und Wirtschaftsmuseum in Wien

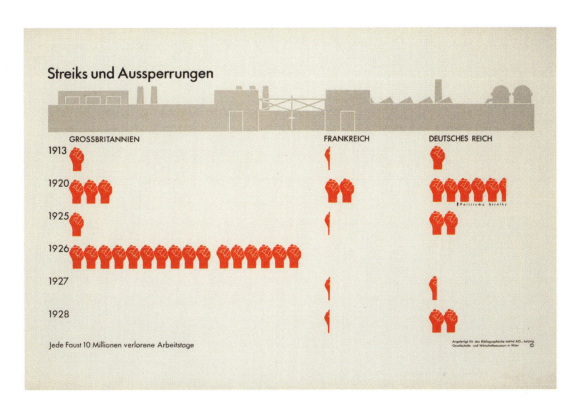

Streiks und Aussperrungen

	GROSSBRITANNIEN	FRANKREICH	DEUTSCHES REICH
1913			
1920			
1925			
1926			
1927			
1928			

Jede Faust 10 Millionen verlorene Arbeitstage

Angefertigt für das Bibliographische Institut AG., Leipzig
Gesellschafts- und Wirtschaftsmuseum in Wien

Economic activity in the world

Published in *Gesellschaft und Wirtschaft*, 1930

Man and industry in one image: the regions of the world are indicated by the typical headgear and skin color of their populations, while the various industries – 'primitive', 'traditional' and 'modern' – are symbolized by signs for bow-and-arrow, hammer and cogwheel respectively.

Wirtschaftsformen der Erde

Zahnrad: Moderne Wirtschaft (Industrie im Vordergrund)
Hammer: Altkulturwirtschaft (Handwerk und Ackerbau entwickelt)
Pfeil und Bogen: Primitive Wirtschaft (Sammeln, Jagen, primitive Landwirtschaft)

Jede Figur 100 Millionen Menschen Schätzung für 1930

Angefertigt für das Bibliographische Institut AG, Leipzig
Gesellschafts- und Wirtschaftsmuseum in Wien

The paintings' subjects

Part of the exhibition *Rondom Rembrandt* at the Bijenkorf, Amsterdam, Den Haag, Rotterdam, 1938, by the International Foundation for Visual Education, The Hague

This chart was shown as a poster in the exhibition 'Around Rembrandt' at the Bijenkorf department stores. Arntz remarked: 'For the first time in the Netherlands, art has been introduced in an educational manner. Through charts, the exhibition illustrated the historical events and the social and economical backgrounds of the Dutch Golden Age. With visual statistics and photographs, a clear and orderly explanation was given of Rembrandt's life, his subjects, past and presents attributions, the relationship between study and painting and the changing ownership of his paintings...' *(Gerd Arntz. Kritische grafiek en beeldstatistiek)*

De onderwerpen van de schilderijen

bij Rubens

altaarstukken

bijbelse
onderwerpen
(niet voor de kerk)

mythologische
en historische
onderwerpen

portretten

genre en
landschap

bij Rembrandt

bijbelse
onderwerpen
(niet voor de kerk)

mythologische
en historische
onderwerpen

portretten

zelfportretten

genre en
landschap

Elk symbool stelt voor 5% van het aantal schilderijen

How long do animals live?

Published in Compton's pictured Encyclopedia, 1939

How Long Do Animals Live?

insect · rat, mouse · 5 · hare · toad · fox · squirrel · eel · earthworm · 10
chicken · canary · dog · cat · 15 · woodpecker · wolf · sheep · lion · reindeer · blackbird
20 · elk · crocodile · raven · heron · 25 · gull · dove · ostrich · carp · horse · dromedary · 30
hippopotamus · crane · 35 · owl · bear
40 · 45 · swan · parrot · goose · 50
elephant · 55 · rhinoceros
60 · 65 · pearl mussel · whale · 70
80 · 90
100 · 110
120 · 130
140 · giant tortoise · 150

red: mammals black: birds blue: other vertebrates yellow: invertebrates

Average ages which certain animals may be expected to reach, based on reports of zoos and estimates of biologists. Individuals have been reported as far older. (Data from Field Museum of Natural History.)

Prepared for Compton's
Pictured Encyclopedia
© International Founda-
tion for Visual Education

198

Raw materials

Published in *Modern man in the making*, 1939

Gerd Arntz: 'Publisher Alfred Knopf gave Neurath complete freedom to write an educational book according to his own insights. This became *Modern man in the making – A report on joy and fear*, which was published between 1939 and 1940 in the United States, England and the Netherlands and in 1949 in Scandinavia. 'Modern Man' was the last collaborative endeavour of Neurath and myself.' *(Gerd Arntz. Kritische grafiek en beeldstatistiek)*

Raw Materials

United States and Canada

Europe

Soviet Union

Latin-America

Southern Territories

Far East

Each full coloured symbol represents 10% of world production on ship: exported outlined, on white ship: imported
pig iron, rubber, cotton, wool, linen, rayon, silk

Silhouettes of War Economy

Published in *Modern man in the making*, 1939

This graph, published in 1939, i.e. at the eve of the second World War, shows two of four speculations on possible alliances for the next war, based on the power over raw materials necessary for the war effort. The graphs show how the balance of power shifts dramatically, depending especially on which side the United States and the Soviet Union take. Neurath: 'These schemes show only how the question of war can be discussed in concrete cases. Readers should not object that alliances are depicted which seem queer to them; a scheme is not a fact, and necessity makes strange bedfellows.'

Silhouettes of War Economy

	Great Britain, France, Spain, Poland, Rumania, Hungary, Yugoslavia, Turkey, Iraq, Iran	United States, Soviet Union and other countries	Germany, Italy, Japan
Coal			
Petroleum			
Iron (content of ores)			
Copper (content of ores)			
Cotton and wool			
Grain and rice			

	United States, Great Britain, France, Italy, Spain, Rumania, Hungary, Yugoslavia, Turkey, Iraq, Iran	Other countries	Soviet Union, Germany, Japan, Poland
Coal			
Petroleum			
Iron (content of ores)			
Copper (content of ores)			
Cotton and wool			
Grain and rice			

Each symbol represents 10 % of world production

84

Economic scheme

Published in *Modern man in the making*, 1939

Neurath: 'A bird's-eye view of the interconnexions between all the parts of a society in action makes it possible to analyze the state of the world or structure of a single country. The general scheme remains the same.'

Economic Scheme

Use of natural resources

Semi-manufacturing

Manufacturing

Distribution and service

Each man symbol represents 5 per thousand population

young people

people working within economic scheme

housewives, students etc.

old people

ISOTYPE

Visitors of entertainment institutions in 1939
Statistisch zakboek (Statistical Pocket Book), 1940

Each figure represents 2 million tickets sold for respectively cinema, exhibitions, sports and other kinds of entertainment.

Aantal bezoekers aan vermakelijkheidsinstellingen in 1939

Bioscoop

Tentoonstellingen

Sport

Overige

Elk figuurtje stelt 2 millioen verkochte toegangsbewijzen voor

C.B.S. 712

Ned. Stichting
voor Statistiek

A statistical research

Spring Fair, 1941, Statistics Netherlands stand

'When the Government, business or science desires a certain statistics, the Central Committee for Statistics will research whether there is the need for this. If this is the case, this committee will grant permission to the Central Bureau for Statistics.' The scheme charts the process from decision making, via collaboration of experts in gathering information, to checking and sorting the material.

1. Indien de Overheid, het bedrijfsleven of de wetenschap een bepaalde statistiek wenscht onderzoekt de Centrale Commissie voor de Statistiek of hieraan behoefte bestaat. Is dit het geval, dan geeft deze commissie haar toestemming aan het Centraal Bureau voor de Statistiek

Bedrijfsleven Overheid Wetenschap

Centrale Commissie voor de Statistiek

2. In samenwerking met deskundigen uit de praktijk worden de vraagformulieren vastgesteld.

Centraal Bureau voor de Statistiek

3. Jaarlijks uitgezon

Fabrika

Winkelier

oenen formulieren
ontvangen.

4. Nauwkeurige contrôle en
 uitgebreide correspondentie,
 dikwijls ook accountantsbezoek,
 zijn noodzakelijk om
 het grondmateriaal van
 zijn fouten te ontdoen.

5. Het grondmateriaal wordt
 gesorteerd, gedeeltelijk
 met den sortergraaf.

erkeersteller

Correspondentie

Particulier

Accountantsbezoek

Secretarie

Contrôle

Sortergraaf

What could one buy for one guilder?

Published in *'Wie Wat Waar'* (Who, What Where?), statistical yearbook, 1947

The 'Who, What, Where' yearbooks were published since 1937 till the mid-1980s (with the exception of 1945 and 1946). These books listed the year's most prominent people, the most important events and where they happened. Apart from the facts and figures of the time, they also featured background articles on a wide range of topics. This graph shows the impact of the war on household budgets.

Wat kon men voor een gulden koopen?

1914

witbrood (x 2 stuks)
of

eieren (x 5 stuks)
of

melk (x 2 liter)
of

aardappelen(x 5 kg)
of

roomboter (x 1 ons)
of

koffie (x 1 ons)
of

suiker (x 1 pond)
of

runderlappen
(x ½ pond)

1939

witbrood (x 2 stuks)
of

eieren (x 5 stuks)
of

melk (x 2 liter)
of

aardappelen (x 5 kg)
of

roomboter (x 1 ons)
of

koffie (x 1 ons)
of

suiker (x 1 pond)
of

runderlappen
(x ½ pond)

1946

witbrood (x 2 stuks)
of

eieren (x 5 stuks)
of

melk (x 2 liter)
of

aardappelen(x 5 kg)
of

roomboter (x 1 ons)
of

koffie (x 1 ons)
of

suiker (x 1 pond)
of

runderlappen
(x ½ pond)

Size of cattle and swine stock

Statistical pocket book, 1947/'48

Growth of the Netherlands' farm animal stock with predictable dips during the war years. Cattle are divided between milk-cows and calves (red) and other cattle (black). Pigs are younger than 6 weeks (black) or older (red). Each figure represents 200.000 animals.

Grootte van de rundveestapel

Grootte van de varkensstapel

Number of graduates

Statistical pocket book, 1950

Number of graduates of Grammar school (α (language) or β) (science) orientation) and high school in the Netherlands. Each figure is 200 graduates. Boys: black, girls: white.

Average life span

Statistical pocket book, 1951

Average life span in the Netherlands at the time of birth. Note how the figures' clothing evolves with the time, as an extra layer of information.

Aantal geslaagden voor de eindexamens gymnasium en H.B.S.

Elk figuurtje stelt 200 voor het eindexamen geslaagde leerlingen voor zwart: jongens wit: meisjes

C.B.S. 100.49/7

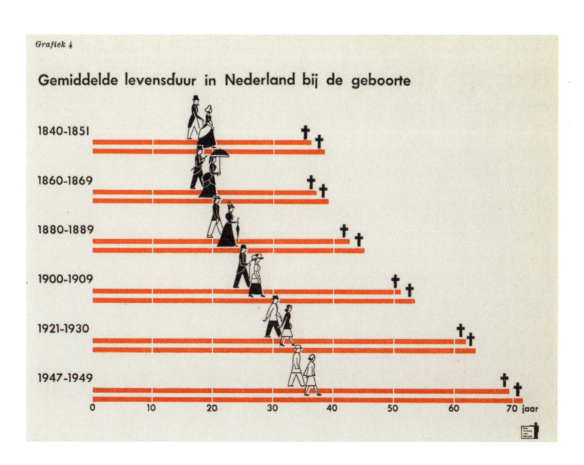

Grafiek 4

Gemiddelde levensduur in Nederland bij de geboorte

Studying for teacher

Statistical pocket book, 1951

Amount of students training to become teachers. Each figure
represents 1000 persons. After 1948, there is a strong increase
in female teachers.

Aantal personen in opleiding voor onderwijzer

1938

1946

1948

1950

1951

Elk figuurtje stelt 1000 personen voor

Motor vehicles in the Netherlands

Statistical pocket book, 1951

Motor cycles and mopeds, cars and busses, and trucks and other special vehicles, respectively. The symbol for the moped is derived from the 'Solex', a bicycle with small motor mounted directly on top of the front wheel, which was very popular in the Netherlands in the 1950s. Each figure represents 20.000 vehicles.

Ontwikkeling van het Nederlandse motorrijtuigenpark

motorrijwielen, motordriewielers, rijwielen met hulpmotor:

1939

1946

1948

1950

1951

personenauto's, autobussen

1939

1946

1948

1950

1951

vrachtauto's, trekauto's, speciale voertuigen

1939

1946

1948

1950

1951

Elk teken stelt 20 000 motorrijtuigen voor

visual stories

Gerd Arntz drew over 4000 symbols and small illustrations for the Isotype visual dictionary and other commissions. The pictograms (or *Signaturen*, as Neurath and Arntz called them) symbolize key data from industry, demographics, politics and economy. Isotype symbols should be instantly recognizable, without any distracting detail. What counts is the general idea. The pictograms and small illustrations in this chapter are scanned from the original prints in the Arntz archive of the Municipal Museum The Hague. This accounts for some irregularities, which resulted from hand printing the linocuts. Our only intervention concerns the background (usually brown or brownish paper) which was whitened to emphasize the contours of the drawings, whilst keeping the authenticity of the outlines intact. We have arranged them in a way that suggests a use beyond the strict confines of information graphics: since these small images together constitute a visual language, one can write little stories in them...

isotype
overview

The vast collection of images from Gerd Arntz's archive in the Municipal Museum The Hague contains quite a few variants of the same or similar pictograms. For each different size, each outline, fill or half-tone and each different color a separate linocut had to be made by hand. Also, the style of some figures changes over the years. One can, for instance, follow the evolution of car design after the early 1930s in the changing pictograms Arntz drew for them.

On the following pages a selection of around 600 figures can be viewed, which can also be found on the Gerd Arntz web archive (www.gerdarntz.org). We have grouped them in a number of categories to enable the reader to see them in context, to compare and contrast similar forms and subjects. The filenames of the Isotypes are the ones under which the digital versions of the prints are archived in the Municipal Museum The Hague.

Architecture

GMDH02_00162

GMDH02_00163

GMDH02_00165

GMDH02_00167

GMDH02_00187

GMDH02_00188

GMDH02_00224

GMDH02_00228

GMDH02_00229

GMDH02_00293

GMDH02_00334

GMDH02_00335

GMDH02_00371

GMDH02_00409

GMDH02_00551

GMDH02_00561

GMDH02_00563

GMDH02_00571

GMDH02_00613

GMDH02_00614

GMDH02_00677

GMDH02_00723

GMDH02_00728

GMDH02_00741

GMDH02_00827

GMDH02_00861

GMDH02_00874

GMDH02_01023

At work

GMDH02_00092

GMDH02_00139

GMDH02_00140

GMDH02_00141

GMDH02_00142

GMDH02_00274

GMDH02_00308

GMDH02_00338

GMDH02_00340

GMDH02_00355

GMDH02_00362

GMDH02_00374

GMDH02_00377

GMDH02_00378

GMDH02_00380

GMDH02_00381

GMDH02_00384

GMDH02_00494

GMDH02_00496

GMDH02_00498

GMDH02_00500

GMDH02_00501

GMDH02_00502

GMDH02_00512

GMDH02_00515

GMDH02_00518

GMDH02_00536

GMDH02_00546

GMDH02_00555

GMDH02_00567

GMDH02_00651

GMDH02_00653

GMDH02_00654

GMDH02_00655

GMDH02_00656

GMDH02_00657

GMDH02_00660

GMDH02_00661

GMDH02_00664

GMDH02_00666

GMDH02_00667

GMDH02_00670

GMDH02_00688

GMDH02_00689

GMDH02_00690

GMDH02_00696

GMDH02_00700

GMDH02_00707

GMDH02_00709

GMDH02_00717

GMDH02_00718

GMDH02_00719

GMDH02_00720

GMDH02_00727

GMDH02_00765

GMDH02_00768

GMDH02_00804

GMDH02_00805

GMDH02_00818

GMDH02_00819

GMDH02_00820

GMDH02_00843

GMDH02_00848

GMDH02_00849

GMDH02_00851

GMDH02_00853

GMDH02_00854

GMDH02_00855

GMDH02_00856

GMDH02_00857

GMDH02_00858

GMDH02_00877

GMDH02_00891

GMDH02_00949

GMDH02_00950

GMDH02_00951

GMDH02_00954

GMDH02_00956

GMDH02_00957

GMDH02_00958

GMDH02_00959

GMDH02_00960

GMDH02_00961

GMDH02_00964

GMDH02_00965

GMDH02_00966

GMDH02_00993

GMDH02_00995

GMDH02_00996

GMDH02_00997

GMDH02_00998

GMDH02_00999

GMDH02_01000

GMDH02_01001

GMDH02_01002

GMDH02_01003

GMDH02_01004

GMDH02_01005

GMDH02_01008

Food

GMDH02_00001

GMDH02_00008

GMDH02_00016

GMDH02_00024

GMDH02_00026

GMDH02_00027

GMDH02_00071

GMDH02_00226

GMDH02_00227

GMDH02_00271

GMDH02_00324

GMDH02_00349

GMDH02_00366

GMDH02_00503

GMDH02_00504

GMDH02_00523

GMDH02_00558

GMDH02_00564

GMDH02_00575

GMDH02_00602

GMDH02_00687

GMDH02_00698

GMDH02_00714

GMDH02_00731

GMDH02_00756

GMDH02_00757

GMDH02_00759

GMDH02_00760

GMDH02_00762

GMDH02_00767

GMDH02_00810

GMDH02_00832

GMDH02_00833

GMDH02_00842

GMDH02_00847

GMDH02_00859

GMDH02_00860

GMDH02_00862

GMDH02_00863

GMDH02_00866

GMDH02_00989

Industry

GMDH02_00010

GMDH02_00011

GMDH02_00014

GMDH02_00018

GMDH02_00028

GMDH02_00030

GMDH02_00031

GMDH02_00032

GMDH02_00035

GMDH02_00038

GMDH02_00040

GMDH02_00051

GMDH02_00053

GMDH02_00058

GMDH02_00059

GMDH02_00060

GMDH02_00063

GMDH02_00072

GMDH02_00108

GMDH02_00115

GMDH02_00117

GMDH02_00159

GMDH02_00168

GMDH02_00196

GMDH02_00217

GMDH02_00282

GMDH02_00298

GMDH02_00311

GMDH02_00315

GMDH02_00318

GMDH02_00397

GMDH02_00400

GMDH02_00469

GMDH02_00474

GMDH02_00529

GMDH02_00530

GMDH02_00556

GMDH02_00606

GMDH02_00615

GMDH02_00616

GMDH02_00685

GMDH02_00701

GMDH02_00814

GMDH02_00872

GMDH02_00883

GMDH02_00884

Mobility

GMDH02_00041

GMDH02_00044

GMDH02_00045

GMDH02_00046

GMDH02_00061

GMDH02_00064

GMDH02_00069

GMDH02_00110

GMDH02_00112

GMDH02_00178

GMDH02_00210

GMDH02_00220

GMDH02_00221

GMDH02_00299

GMDH02_00309

GMDH02_00312

GMDH02_00398

GMDH02_00402

GMDH02_00403

GMDH02_00404

GMDH02_00406

GMDH02_00407

GMDH02_00410

GMDH02_00411

GMDH02_00414

GMDH02_00418

GMDH02_00419

GMDH02_00420

GMDH02_00437

GMDH02_00442

GMDH02_00547

GMDH02_00573

GMDH02_00577

GMDH02_00608

GMDH02_00691

GMDH02_00716

GMDH02_00721

GMDH02_00740

GMDH02_00751

GMDH02_00772

GMDH02_00821

GMDH02_00823

GMDH02_00868

GMDH02_00869

GMDH02_00870

GMDH02_00871

GMDH02_00879

GMDH02_00889

GMDH02_00899

GMDH02_00906

GMDH02_00907

GMDH02_00922

GMDH02_00930

GMDH02_00931

GMDH02_00932

GMDH02_00935

GMDH02_00936

GMDH02_00937

GMDH02_00972

GMDH02_00973

GMDH02_00984

GMDH02_00985

GMDH02_00988

GMDH02_01025

GMDH02_01034

GMDH02_01039

GMDH02_01040

Nature

GMDH02_00153

GMDH02_00195

GMDH02_00197

GMDH02_00211

GMDH02_00212

GMDH02_00213

GMDH02_00214

GMDH02_00215

GMDH02_00280

GMDH02_00283

GMDH02_00291

GMDH02_00321

GMDH02_00339

GMDH02_00344

GMDH02_00346

GMDH02_00375

GMDH02_00412

GMDH02_00413

GMDH02_00415

GMDH02_00434

GMDH02_00444

GMDH02_00446

GMDH02_00447

GMDH02_00448

GMDH02_00449

GMDH02_00452

GMDH02_00453

GMDH02_00456

GMDH02_00457

GMDH02_00459

GMDH02_00460

GMDH02_00461

GMDH02_00463

GMDH02_00464

GMDH02_00465

GMDH02_00466

GMDH02_00467

GMDH02_00468

GMDH02_00472

GMDH02_00473

GMDH02_00478

GMDH02_00585

GMDH02_01017

People

GMDH02_00056

GMDH02_00075

GMDH02_00079

GMDH02_00081

GMDH02_00082

GMDH02_00084

GMDH02_00086

GMDH02_00094

GMDH02_00096

GMDH02_00100

GMDH02_00118

GMDH02_00119

GMDH02_00120

GMDH02_00122

GMDH02_00123

GMDH02_00125

GMDH02_00134

GMDH02_00136

GMDH02_00138

GMDH02_00144

GMDH02_00145

GMDH02_00146

GMDH02_00147

GMDH02_00148

GMDH02_00150

GMDH02_00152

GMDH02_00155

GMDH02_00158

GMDH02_00180

GMDH02_00181

GMDH02_00183

GMDH02_00193

GMDH02_00272

GMDH02_00275

GMDH02_00290

GMDH02_00292

GMDH02_00305

GMDH02_00326

GMDH02_00350

GMDH02_00351

GMDH02_00353

GMDH02_00358

GMDH02_00367

GMDH02_00368

GMDH02_00376

GMDH02_00386

GMDH02_00388

GMDH02_00391

GMDH02_00392

GMDH02_00422

GMDH02_00425

GMDH02_00426

GMDH02_00428

GMDH02_00435

GMDH02_00436

GMDH02_00476

GMDH02_00481

GMDH02_00483

GMDH02_00484

GMDH02_00486

GMDH02_00487

GMDH02_00490

GMDH02_00509

GMDH02_00520

GMDH02_00522

GMDH02_00526

GMDH02_00540

GMDH02_00541

GMDH02_00542

GMDH02_00545

GMDH02_00548

GMDH02_00562

GMDH02_00565

GMDH02_00578

GMDH02_00579

GMDH02_00582

GMDH02_00584

GMDH02_00588

GMDH02_00593

GMDH02_00594

GMDH02_00596

GMDH02_00609

GMDH02_00620

GMDH02_00631

GMDH02_00631a

GMDH02_00636

GMDH02_00638

GMDH02_00640

GMDH02_00641

GMDH02_00642

GMDH02_00643

GMDH02_00644

GMDH02_00645

GMDH02_00646

GMDH02_00647

GMDH02_00648

GMDH02_00649

GMDH02_00672

GMDH02_00674

GMDH02_00675

GMDH02_00676

GMDH02_00697

GMDH02_00711

GMDH02_00712

GMDH02_00722

GMDH02_00725

GMDH02_00732

GMDH02_00733

GMDH02_00738

GMDH02_00739

GMDH02_00743

GMDH02_00755

GMDH02_00763

GMDH02_00769

GMDH02_00776

GMDH02_00777

GMDH02_00783

GMDH02_00785

GMDH02_00788

GMDH02_00793

GMDH02_00794

GMDH02_00795

GMDH02_00796

GMDH02_00798

GMDH02_00800

GMDH02_00801

GMDH02_00802

GMDH02_00803

GMDH02_00806

GMDH02_00807

GMDH02_00809

GMDH02_00835

GMDH02_00836

GMDH02_00840

GMDH02_00845

GMDH02_00846

GMDH02_00864

GMDH02_00888

GMDH02_00893

GMDH02_00894

GMDH02_00895

GMDH02_00896

GMDH02_00897

GMDH02_00898

GMDH02_00900

GMDH02_00909

GMDH02_00915

GMDH02_00916

GMDH02_00917

GMDH02_00918

GMDH02_00938

GMDH02_00939

GMDH02_00940

GMDH02_00942

GMDH02_00952

GMDH02_00953

GMDH02_00955

GMDH02_00967

GMDH02_00968

GMDH02_00969

GMDH02_00970

GMDH02_00971

GMDH02_00974

GMDH02_00975

GMDH02_00977

GMDH02_00978

GMDH02_00990

GMDH02_01006

GMDH02_01007

GMDH02_01016

GMDH02_01021

GMDH02_01024

GMDH02_01029

GMDH02_01030

GMDH02_01031

Products

GMDH02_00037

GMDH02_00039

GMDH02_00111

GMDH02_00114

GMDH02_00157

GMDH02_00161

GMDH02_00184

GMDH02_00189

GMDH02_00200

GMDH02_00216

GMDH02_00222

GMDH02_00223

GMDH02_00277

GMDH02_00294

GMDH02_00314

GMDH02_00316

GMDH02_00319

GMDH02_00323

GMDH02_00328

GMDH02_00329

GMDH02_00333

GMDH02_00336

GMDH02_00364

GMDH02_00394

GMDH02_00399

GMDH02_00433

GMDH02_00470

GMDH02_00491

GMDH02_00492

GMDH02_00493

GMDH02_00505

GMDH02_00506

GMDH02_00524

GMDH02_00527

GMDH02_00528

GMDH02_00532

GMDH02_00537

GMDH02_00539

GMDH02_00570

GMDH02_00572

GMDH02_00600

GMDH02_00603

GMDH02_00621

GMDH02_00634a

GMDH02_00635

GMDH02_00679

GMDH02_00680

GMDH02_00682

GMDH02_00683

GMDH02_00692

GMDH02_00694

GMDH02_00695

GMDH02_00706

GMDH02_00708

GMDH02_00726

GMDH02_00746

GMDH02_00748

GMDH02_00749

GMDH02_00750

GMDH02_00752

GMDH02_00753

GMDH02_00754

GMDH02_00775

GMDH02_00815

GMDH02_00822

GMDH02_00873

GMDH02_00876

GMDH02_00881

GMDH02_00914

GMDH02_00980

GMDH02_00981

GMDH02_00982

GMDH02_01015

GMDH02_01018

GMDH02_01019

GMDH02_01026

Various

GMDH02_00102

GMDH02_00176

GMDH02_00185

GMDH02_00207

GMDH02_00208

GMDH02_00284

GMDH02_00327

GMDH02_00331

GMDH02_00359

GMDH02_00361

GMDH02_00393

GMDH02_00479

GMDH02_00533

GMDH02_00544

GMDH02_00553

GMDH02_00586

GMDH02_00724

GMDH02_00730

GMDH02_00736

GMDH02_00771

GMDH02_00811

GMDH02_00812

GMDH02_00813

GMDH02_00817

GMDH02_00826

GMDH02_00829

GMDH02_00830

GMDH02_00834

GMDH02_00867

GMDH02_00875

GMDH02_00887

GMDH02_00892

GMDH02_00913

GMDH02_00979

lovely language words divide images unite

Bauer Otto Neurath Visualisierungen **Bildersprache**

Ferdinand Mertens *Otto Neurath*

Modern Man in the Making · O

Neurath & Kinross The transformer

gerd arntz

Gerd Arntz De tijd onder het mes

GERD ARNTZ - POLITIEKE PRENTEN TUSSEN TWEE OORLOGEN

EEN WERELDVERBETERAAR IN DEN HAAG

Literature

Listed here is a selection of books about Gerd Arntz, Otto Neurath and/or ISOTYPE and books written by Otto Neurath himself. Regrettably most of the books are only available in some antiquarian bookshops.

Ed Annink, Max Bruinsma, *Lovely Language. words divide, images unite*, 2008
ISBN 978 90 8690 127 2, Veenman Publishers, Rotterdam

Gerd Arntz, Kees Broos, *Symbolen voor onderwijs en statistiek: 1928-1965 Wenen-Moskou-Den Haag*, 1979
ISBN 90 70115 08 5, Mart Spruijt, Amsterdam

Erwin K. Bauer, Frank Hartmann, *Bildersprache, Otto Neurath Visualisierungen*, 2006
ISBN 978 3708900001, WUV Universitätsverlag, Vienna

Uli Bohnen, Kees Vollemans, *Gerd Arntz. Politieke prenten tussen twee oorlogen*, 1973
ISBN 90 6168 063 8, SUN Nijmegen

Flip Bool, Kees Broos, *Gerd Arntz. Kritische grafiek en beeldstatistiek*, 1976
ISBN 978 9061681137, Gemeentemuseum The Hague, The Hague

Kees Broos, *Gerd Arntz. De tijd onder het mes: hout en linoleumsneden 1920-1970*, 1988
ISBN 9061682908, SUN Nijmegen

J.A. Edwards, Michael Twyman, *Graphic communication though ISOTYPE*, 1975
Department of Typography and Graphic Communication, University of Reading

Nigel Holmes, *Pictograms: A view from the drawing board or, what I learned from Otto Neurath and Gerd Arntz (and jazz)*, 2000-2001

ISSN 0142-5471, Information Design Journal, 2000-2001, vol. 10, no2, pp. 133-143

Ferdinand Mertens, *Otto Neurath, en de maakbaarheid van de betere samenleving*, 2007
ISBN 978 90 5260 262 2, Aksant, Amsterdam, Sociaal Cultureel Planbureau, The Hague

Ferdinand Mertens, *Een wereldverbeteraar in Den Haag. De Haagsche ballingschap van Otto Neurath*, 2007
ISBN 978 90 808671 2 3, Municipality of The Hague

Marie Neurath, Robin Kinross, *The transformer, principles of making Isotype charts*, 2009
ISBN 978 0 907259 40 4, Hyphen Press, London

Otto Neurath, *Basic by ISOTYPE*, 1937
Kegan Paul, Trench, Trubner & Co, London

Otto Neurath, *Gesellschaft und Wirtschaft*, 1930
Bibliographisches Institut ag, Leipzig

Otto Neurath, *International picture language. The first rules of Isotype*, 1936
Kegan Paul, Trench, Trubner & Co, London

Otto Neurath, *Modern man in the making*, 1939
Knopf, New York

Nader Vossoughian, *Otto Neurath. The Language of the Global Polis*, 2008
ISBN 978 9056623500, NAi Publishers, Rotterdam

Exhibition *Lovely Language*, Centraal Museum Utrecht, 2007.

GERD ARNTZ

1900-1988

Photo credits

Page 1-13; Collection Gemeentemuseum The Hague

Page 18; Photo by Marsel Loermans

Page 24; Photo by Tineke Bonarius van Os, collection Gerd Arntz / Arntz heirs

Page 26, 30, 36, 39, 40, 42, 44, 46, 51, 54-64; Collection Gerd Arntz / Arntz heirs

Page 28; Private collection

Page 32; Photo by Max Bruinsma, collection Gemeentemuseum The Hague

Page 49; Photo by Wolfgang Suschitzky, collection Gerd Arntz / Arntz heirs

Page 52, 66, 77; Photo by Pieter Boersma

Page 73; Photo by Roel Stevens

Page 83, above; Courtesy of the Otto and Marie Neurath Isotype Collection, University of Reading

Page 83, below; Scanned from *International Picture Language*

Page 102, 107, 111, 112, 114, 117, 118, 121; Scanned from *Gerd Arntz. De tijd onder het mes*
© c/o Pictoright Amsterdam 2009

Page 108; Photo by Pieter Boersma, Collection Gemeentemusem The Hague
© c/o Pictoright Amsterdam 2009

Page 125, 127, 129, 131, 133; Collection Gemeentemuseum The Hague

Page 135; Courtesy of the Otto and Marie Neurath Isotype Collection, University of Reading

Page 137, 139, 141; Scanned from *Modern man in the making*

Page 143, 144, 147, 149, 151, 153, 155; Collection Gemeentemuseum The Hague

Page 158-247, 250-280; Collection Gemeentemuseum The Hague

Page 282; Photo by Menno Wigmore

Page 284; Photo by Roel Stevens

Credits

This book is an initiative of Ed Annink,
Ontwerpwerk, The Hague
www.ontwerpwerk.com

Edited by
Ed Annink, Max Bruinsma
Research and assistance
Laura van Uitert, Ontwerpwerk, The Hague
Text contributions by
Ed Annink, Flip Bool, Max Bruinsma,
Gert Dumbar, Mieke Gerritzen, Nigel Holmes,
Max Kisman, Paul Mijksenaar,
Erik Spiekermann and Kees Vollemans
Translation from the Dutch
Max Bruinsma, Jan Wynsen
Design
Ontwerpwerk, The Hague
Printed by
Pozkal, Poland

© 2010 010 Publishers, Rotterdam /
www.010.nl
ISBN 978-90-6450-763-2

Acknowledgements
In 2008, Ontwerpwerk launched the Gerd Arntz
web archive (www.gerdarntz.org), an initiative
made possible through the financial support
of Statistics Netherlands (CBS).
The project included the digitization of the
Arntz Collection at The Hague's Municipal
Museum, by the organization Memory of the
Netherlands. We thank all three parties for
their involvement, enabling us to reproduce
a great number of Isotypes in this book.
We would like to express our special gratitude
to Peter Arntz (1924-2009) for all the help he
has offered us, not only in producing this
particular book but in all other projects relating
to his father's work as well. Peter's recollec-
tions proved to be extraordinarily detailed
for a man of his advanced age. With great
enthusiasm, at both private and public
occasions, he told us about his father's life
and work, as well as sharing with us exclusive
and very personal items of his father's. Sadly,
Peter Arntz didn't live to see the publication
of this book – he passed away on August 6th,
2009. We thank Marian and Anouk Arntz as
well as John van der Ree for continuing the
project Peter could not finish: making the
knowledge of Gerd Arntz's inspiring work
available to the larger public.
We also like to thank Pieter Boersma,
Flip Bool, Gert Dumbar, Gemeentemuseum
The Hague, Mieke Gerritzen, Nigel Holmes,
Max Kisman, Paul Mijksenaar, Wolfgang
Suschitzky, Erik Spiekermann, University
of Reading / Department of Typography &
Graphic Communication and Kees Vollemans.

Drawn by Miriam Zink during her internship at Ontwerpwerk.